ART FORMS FROM PLANT LIFE

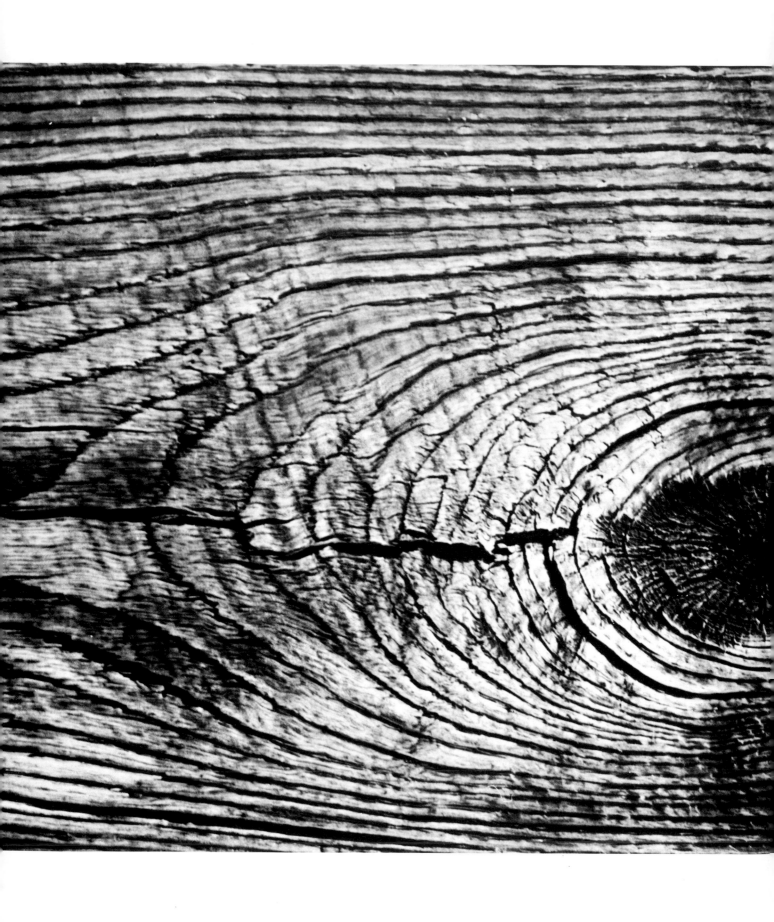

ART FORMS FROM PLANT LIFE

WILLIAM M. HARLOW

*Professor Emeritus, SUNY College of
Environmental Science and Forestry,
Syracuse*

DOVER PUBLICATIONS, INC.

NEW YORK

Published in Canada by General Publishing Company, Ltd.,
30 Lesmill Road, Don Mills, Toronto, Ontario.
Published in the United Kingdom by Constable and
Company, Ltd., 10 Orange Street, London WC 2.

This Dover edition, first published in 1976, is a revised and
expanded version of the work originally published in 1966 by
Harper & Row, Publishers, New York, under the title *Patterns
of Life: the Unseen World of Plants*. The reproductions of
the male cones of jack pine and the flowers of sugar maple
and willow are from *Textbook of Dendrology* (5th ed.) by
W. M. Harlow and E. S. Harrar, McGraw-Hill Book Co., 1968.

DOVER *Pictorial Archive* SERIES

Art Forms from Plant Life belongs to the Dover Pictorial
Archive Series. It is sold with the understanding that illustra-
tions may be reproduced for advertising or editorial purposes
without payment or special permission. Such permission is,
however, limited to the use of not more than three illustrations
in any single publication. Please address the publisher for per-
mission to make more extensive use of the illustrations in this
volume. The author will appreciate the usual credit line,
although such credit is not a requirement. For use of individual
pictures on a non-exclusive basis wherein photographic prints
are necessary, please write to Dr. W. M. Harlow, 1568 West-
moreland Avenue, Syracuse, New York 13210.

International Standard Book Number: 0-486-23262-X
Library of Congress Catalog Card Number: 75-25002

Manufactured in the United States of America
Dover Publications, Inc.
180 Varick Street
New York, N.Y. 10014

To Alma, My Wife

Preface

Between the world as seen by the naked eye and that visible through a microscope there lies a realm of form, texture, and color largely unknown to most people. Yet this remarkable universe can be explored with nothing more than a hand lens or pocket magnifier. In a lifetime one can explore only a few pathways through this middle-sized world of plants and animals.

The pictures on the following pages not only reveal beauty of structure but in many cases show how plants respond or adapt to their environment, not only during the lifetime of the individual plant but also over millions of years. These plant patterns, though rarely seen because of their small size, may provide students, designers, and others with new and exciting departures for creative expression.

A copy of this book was given to one of our Oriental graduate students. After turning a few of its pages, he closed it carefully and said, "I shall look at only one of these pictures a day, study it, and try to extract its meaning." Very few of us in the Western world—bombarded as we are by thousands of images each day—would ever think to react in this way.

W. M. H.

Notes on Plant Characteristics

Leaves. Often the shape, size, margin, and arrangement of a leaf are all that is needed to identify a plant. Because certain groups of plants always have a typical leaf placement, the arrangement of the leaves on the stem is an important part of identification. Leaves are either alternate and arranged singly in spirals—or opposite—that is, paired. A few plants have whorled leaves, with three or more at the same height on the stem.

Usually, opposite or whorled leaves are easily recognized, but alternate leaves may present problems. If twig or stem growth is very slow, alternate leaves may be so crowded that they appear to be opposite or whorled. The solution is to look for stems growing normally on the plant; here it will be more obvious that the leaves occur singly.

Another problem in determining arrangement is that of whether or not a leaf is simple and one-bladed, or compound, with a number of leaflets. In some compound leaves, such as those of the horsechestnut, the usual seven leaflets radiate from the end of the leaf stem. The leaflets of most compound leaves, however, including those of hickory, ash, and walnut, have a different placement. These pinnate or "featherlike" leaves consist of a straight stem with lateral leaflets attached on both sides, and usually with an end or terminal leaflet at the tip. Leaf arrangement does not refer to the placement of the leaflets on the midrib, but only to the way in which the leaf itself, simple or compound, is attached to the woody axis of the plant. In broad-leaved trees and other woody plants, if one follows the leaf from tip to base, there will usually be found, except in the early spring, a bud where the leaf joins the twig.

Most broad-leaved trees are deciduous, bare in winter and leafing out again the next spring. By contrast, most needle-leaved trees—pines, spruces, firs—retain the leaves they developed the previous summer, and are "evergreen." This does not mean that these trees never lose their leaves, but only that the last season's leaves remain at least until the new ones emerge in spring. The leaves of most evergreens are shed after three to five years; in a few species, they may be retained much longer. Variations in leaf margins, shapes of apex and base, types of veining, and other features, are best learned when the leaves are collected and their identity determined with a tree manual or reliable handbook.

Perhaps the most fascinating thing about leaves is their dissimilarity: the fact that no two are exactly the same size and shape. This means that one must learn the range of variation of the different species. The tuliptree, for example, has leaves which are quite similar, one to the other, but the shapes of oak leaves are highly variable, both on the same tree and from one region to another.

Flowers. The word "flower" usually suggests large showy petals such as those of the rose, poppy, iris, lily, magnolia, and the

hundreds of others with which man has surrounded himself. Plants in the wild often have small flowers, however; in trees, especially, these are often so small and inconspicuous as to pass unnoticed. Be that as it may, the beauties of their structure will reward anyone who examines them with a hand lens.

In many species of trees, male (staminate) flowers and female (pistillate) flowers are borne on the same tree; such species are called *monoecious,* from two Greek words meaning in one house. In *dioecious* species, "two houses," the male flowers are borne on one tree, the female on another.

Fruits. A fruit, quite simply, is a ripened ovary containing one or more seeds. On page 50 is shown the pistil of a walnut tree; the lower portion is the ovary. It must now be emphasized that in nature there is the utmost variation of fruit types, just as there is in the flowers that precede them. It has been said that "Man, the observer and cataloguer, looks at nature and for convenience desires, imagines, and describes *uniformity.* Actually, there is infinite *variety;* between the two there is constant conflict." The seed-bearing part of pines, spruces, and most other conifers is a cone. The seeds are borne naked (no ovary) on the surface of the scales.

The word "fruit" has many different meanings, and, perhaps unfortunately, everyone is sure that he knows exactly what the right one is. To give a technical meaning to such a common and loosely used word poses problems for the amateur seeking to understand the language of botanists. Quite often the type of fruit cannot be determined with confidence merely by looking at it, or even by dissecting it. One must watch while its precursor, the flower, slowly develops into the mature fruit.

Seeds. Perhaps the unequaled expression of the plant world is the seed. Each is like a miniature spaceship containing a new plant, the embryo, and a limited amount of food and water for a trip. In some plants, germination begins as soon as the seed lands in a suitable place, but in many others, it loses most of its water and the embryo sinks into a state of lethargy, requiring little oxygen and remaining dormant for months or even years. In temperate-climate plants, the seeds of many species must experience winter before they will germinate. This safeguards them from making false starts during unusually warm periods in the late autumn.

Buds. Buds are only conspicuous in early spring, yet new buds appear as the leaves grow from their developing twigs in May and June at the latitude of New York, and earlier farther south. These buds may be found in the axil or angle between the leaf and the twig, but it is not until late summer or early autumn that they are fully formed.

Since the buds of woody plants are present for most of the year and have conspicuous features of structure and color, their recognition is important. Buds are of two types: a bud may be *terminal,* on the end of the twig; or *lateral,* growing at some point along the side of the twig. Trees with terminal buds also have laterals, but in some groups, such as the birches, elms, and basswoods, no true terminal bud ever forms. As summer advances, there comes a time when length-growth slows and finally stops altogether. The slender tip of the twig then shrinks and dies back to the last well-formed lateral bud, now called the *false terminal* bud. The shriveled twig tip usually falls off leaving a minute round scar on the twig. A true terminal bud is generally larger than a false terminal and points straight ahead. Since buds occur in the leaf axils, except for the terminal bud, their arrangement on the twig is the same as that of the leaves.

Twigs. Significant twig features are type of pith, leaf scars, color, odor, and taste. When one slices a twig lengthwise with a sharp knife, most species show a homogeneous

pith. Exceptions are the walnuts, including the butternut, which have crosswise partitions separating empty chambers, and the tupelos in which the solid pith shows crosswalls of a darker tissue.

Some time before autumn frosts, a special layer of loose, easily ruptured cells develops at the base of each leaf stem. Beneath this layer another layer of corky tissue forms next to the twig. It is not until the leaf falls off or is blown away that this corky layer, the leaf scar, appears on the twig. Then small patches or bundle scars mark the position of the sap-carrying and food translocating channels which passed from twig to leaf. The leaf scar with its bundle scars often looks like a tiny gargoyle's face (p. 9).

In some trees, the color of the twig is an important characteristic. For example, the golden color of a variety of white willow, the bright red of red-stemmed dogwood, the green of sassafras, and recognizable shades of greenish-brown or other colors are examples which help in identification.

The odor and taste of a twig may provide a practical clue to its identity. Yellow and black birch have a wintergreen flavor, sassafras has a spicy taste, and the cherries taste of bitter almond. A few tropical species in Florida and other southern states have twigs which are very poisonous to chew. Also, be certain you can recognize poison-ivy, poison-oak, and poison-sumac before tasting any twig.

Bark. This is another important but variable feature used in tree recognition. As the young tree grows in diameter, more and more phloem layers are produced on the outer face of the cambium while new woody layers are added within (see ring patterns, pp. 94, 95). When the phloem layers outside the cambium accumulate sufficiently, an irregular layer or series of narrow curved patches of reactivated cells, the *cork cambium*, appears somewhere between the outside of the tree and the cambium. This de-velopment cuts off the outer phloem layers from the life of the tree, and they become dead outer bark in contrast to the living inner bark inside the cork cambium. It is important to observe in most trees the changing appearance of the bark, from youth to old age. The young bark of a white birch is brown, for example; it is only when the tree reaches a height of twenty feet or more that the brown bark is sloughed off revealing the typically white layers within. Beeches are an exception to this general rule of age coloration. (See bark patterns, pp. 84 to 87.)

Growth. The growth habits of a plant often assist in identifying it. The plant may creep along the ground or be bushy or treelike in form. Branch patterns and the shape of the crown often confirm recognition. Typical crown shapes develop only in open-growing trees; in the forest, competition with other individuals greatly restricts crown shape. Here all trees tend to have tall straight trunks and small crowns—exactly what the forester desires. Trees which are grown in the open usually yield poor lumber, the many branches along the trunk appearing as knots when a log is sawed.

Habitat. Plants, like animals, tend to find certain environmental niches more suitable than others. There are quite recognizable plant societies associated with differences in available moisture, soil, and temperature. A good example is the bog society which develops in a creeping mat of sphagnum moss around the edges of shallow, poorly drained ponds. From a plane flying across Canada or the northern United States, one may see countless small lakes and ponds slowly filling with a bog society of sphagnum moss, Labrador-tea, leatherleaf, pitcher plant, sheep-laurel, blueberries, and other plants. Behind them, forming the forest, are the black spruce and tamarack.

Spirals. Wherever one looks in the universe there are spirals: from the celestial to the sub-microscopic, from the giant spiral nebu-

lae to the molecules of DNA in living protoplasm. Many of the pictures which follow show spiral structures of great beauty and variety. Shown among others are the twigs of three common trees: basswood, alder, and willow (p. 7). Their buds and leaves, like those of other alternate-leaved plants, not only exhibit an over-all spiral pattern but each represents a different type of spiral.

Spirals have given rise to an interesting series of fractions. In determining them, two buds may be chosen, one exactly above the other. Beginning with the lower bud, an upward turn is described until the bud directly above the starting point is reached. This relationship between stem turns and bud count is expressed as a fraction, the numerator of which represents the number of whole turns necessary to arrive at the higher bud, the denominator the number of buds counted in that section of the spiral. Part of the series is $\frac{1}{2}$, $\frac{1}{3}$, $\frac{2}{5}$, $\frac{3}{8}$, $\frac{5}{13}$, $\frac{8}{21}$. . . .

Among trees and shrubs, the $\frac{1}{2}$ arrangement is characteristic of basswood and the elms, the $\frac{2}{5}$ of oaks, willows, and poplars. A $\frac{1}{3}$ arrangement is rare, but typical of alder. Dr. R. R. Hirt of the SUNY College of Environmental Science and Forestry at Syracuse discovered that needle bundles in the white pine follow a $\frac{5}{13}$ arrangement. These higher fractions are not easy to determine because of the difficulty in choosing buds, leaves, or needle bundles one exactly above the other.

Wood Structure. Perhaps in all of nature there are no more beautiful or significant patterns than those of the growth layers in trees. Seen in cross section on a stump or log, or in the end of a piece of wood, these ring patterns faithfully indicate the life history of the tree. In good years the rings are wide; in poor years, narrow. What makes a year, or, more properly, a growing season, good or poor? Trees, like all other plants, must have water, and the amount of water

available to the roots is reflected in the ring width. But like other green plants, trees need light, as well; and trees growing under heavy shade have narrow rings even though they may have had plenty of water.

Since the simple sugars, the basic food of the tree, are made in the green leaves, anything that robs a tree of its leaves will reduce the amount of wood laid down. Defoliating insects and fire may have a definite effect on ring width. Temperature variations throughout the growing season normally affect ring width less than a scarcity of water and light. Exceptions are alpine trees which receive ample water and light; in this case, extreme temperature changes largely control their growth.

In places such as the arid Southwest, trees growing apart from one another on dry, well-drained slopes have ring patterns directly reflecting the amount of water they receive each year. Scientists at the Tree Ring Laboratory of the University of Arizona have constructed tree ring calendars beginning at the present time and extending back for thousands of years. Knowing that the life history of trees is recorded in their rings, you may wish to try your hand at interpreting the stories told by the rings on pages 94, 95 before reading the interpretations at the bottom of each page.

On pages 98 to 112 are photographs of wood, most seen in cross section, made from thin sections and illuminated from behind. In each case, the center of the tree is some distance below the bottom of the picture, and the tree grew toward the top of the page. How trees add new growth each season is a mystery to many, including, it seems, to some lumberjacks. One of them was heard to remark that it did no harm to knock the bark off a tree because new rings kept forming at the center and these just pushed the old ones outward!

Actually, between the inner bark and the wood is the remarkable layer of cells called

the *cambium*. During the growing season, these cells, by repeated divisions, form new bark on the outside and new wood upon that of the previous season. Trees grow in length only at their twig and root tips, therefore a nail driven into the bark of a tree six feet above the ground will remain at that height.

In woods of the temperate zones, there are usually visible differences in each ring between the wood formed at the beginning of the growing season and that laid down near its end. The earlywood is liable to be more porous and less dense than the latewood. Usually, this makes the earlywood light in color, the latewood darker. In oak, a so-called *ring-porous* wood (p. 100), the earlywood consists of relatively large sap-conducting tubes which are seen as pores in cross section. The pores abruptly become much smaller in the latewood zone, and most of the latewood is dense, heavy, and strong. In the sycamore (p. 102), the pores are relatively small and uniform in size throughout the ring. Such woods are called *diffuse-porous*.

Both the oak and the sycamore show conspicuous dark radial lines known as *wood rays*, common to all woods. In the oaks, where the rays are especially large, they provide the beautiful silver grain seen on radially cut boards. Redwood (p. 108) and other conifers, unlike the oak and sycamore, have no pores, instead being composed of long hollow fibrous cells. To see them, tear a piece of paper and look at the torn edge with a hand lens.

Notes on Photographic Techniques

The art of discovering, selecting, and posing small plant parts showing beautiful and unusual patterns must precede capturing them on film. Having found something worth photographing, one must decide how to light it, what kind of background is best, and how much to reduce or magnify its size on film and in the final enlarged print.

Several of the prints in this book were made from negatives taken thirty years ago using one of the early 35 mm. cameras with a sliding, focusing, copying attachment. But most of them were made with a modern single lens reflex 35 mm. camera with extension tubes, or bellows attachment.

All of the small objects chosen were posed and photographed indoors using a more or less standard lighting arrangement of two photo floods (a No. 1 and a No. 2) from 1 to 2 feet on either side of the object, and at a vertical angle of about 45°. Although the object may be supported on a piece of glass with the white or black background several inches below it, unwanted reflections may register on the film, especially when using black. A piece of paper makes a suitable white background, but a good black was found difficult to achieve until someone suggested using black velvet, which proved excellent. When an object is photographed against white, unequal lighting produces a slight shadow on one side and gives a desirable feeling of depth or roundness. If the same lighting is used with a black background, one loses the shaded side altogether; therefore the lighting from both sides should be nearly equal.

Most small objects are photographed at one-fourth to three times natural size on 35 mm. film and then enlarged about ten times in the finished print. In this way, one uses the camera and enlarger together as a kind of low-power microscope, and unexpected details of structure and pattern are revealed. To capture the ultimate in detail, the lens diaphragm should not be closed more than about half-way. However, to achieve maximum depth of field, the diaphragm should be stopped down as far as it will go, and often this seems to be the most important of the two factors. Finally, although an exposure meter can be used, careful notes of trial exposures and the results obtained will prove invaluable, and when extension tubes separate lens from camera, exposure time must be increased.

On pages 32–35 there are negative images of vein patterns. A flattened leaf is placed on a light-box, and a negative is made, preferably 2¼ x 2¼ to 4 x 5 inches. Then, using a "slow" copying film, a print is made with a contact printer. You now have on film two identical images except that the blacks and whites are reversed. Using the one with black veins, you now make an enlargement and come out with a negative image on paper in which the veins are white.

The final extension of this technique is to make bas-relief prints. Place both films in contact, and slip one of them slightly out of register on a light-box or against a window. When you see what you like, tape

them together and make a print. You will be delighted. This process has, of course, been known for a long time.

The negative prints of wood structure on pages 99, 103, 106, 109, 112 were made in a different way. A microtome was used to cut large sections of wood about ¾ x 1 inch. After staining and mounting in the usual way, they were used as *negatives* in a large photomicrographic camera. The resulting image on enlarging paper became the finished product with blacks and whites reversed.

As to choice of film, fine grain is needed and this has meant using a slow emulsion. Presently, several of the faster films have greatly improved grain structure so that speed need not be sacrificed. However, since time exposures are used, film speed is of little consequence. The important thing is to choose a good film and developer and then stay with them, learning all you can about their capabilities. Among photographers, in spite of the availability of suitable cameras and lenses the macro-field of plants and animals has hardly been explored. It offers great rewards for those with imagination.

ART
FORMS
FROM
PLANT LIFE

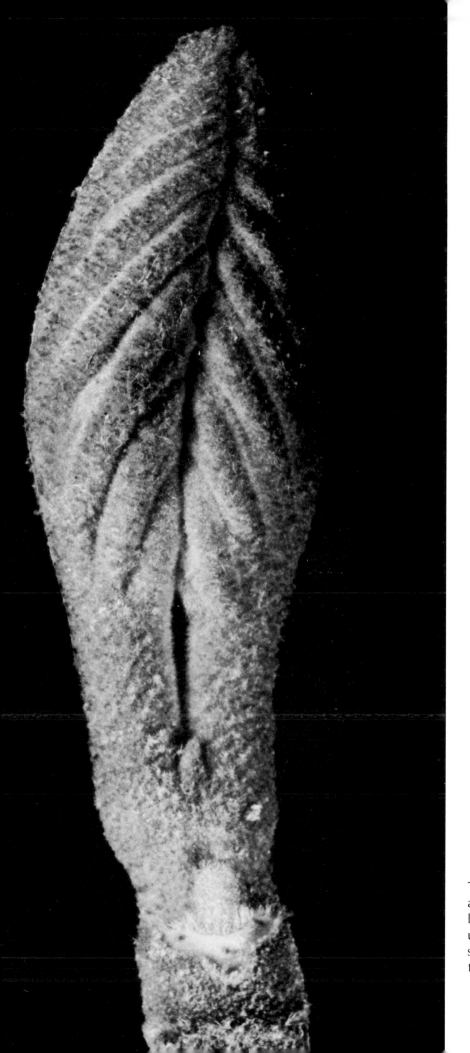

WITCH-HOBBLE BUD, X 12
Viburnum alnifolium Marsh.
The first two leaves of next year's growth
are infolded and thickened in this scale-
less bud. The vein pattern will be on the
underside of the expanded leaf. Such
scaleless or naked buds are common only
to a few trees and shrubs.

1

LEAF BUD AND FLOWER BUD
OF FLOWERING DOGWOOD, X 10
Cornus florida L.
In many trees, leaves and flowers emerge from the same bud; in the flowering dogwood they come from separate and dissimilar buds. The four scales of the large flower bud expand into petal-shaped bracts. Most people think these are real petals, and that they are looking at a single flower. Actually, some twenty separate small greenish flowers are borne in a flat-topped head in the center.

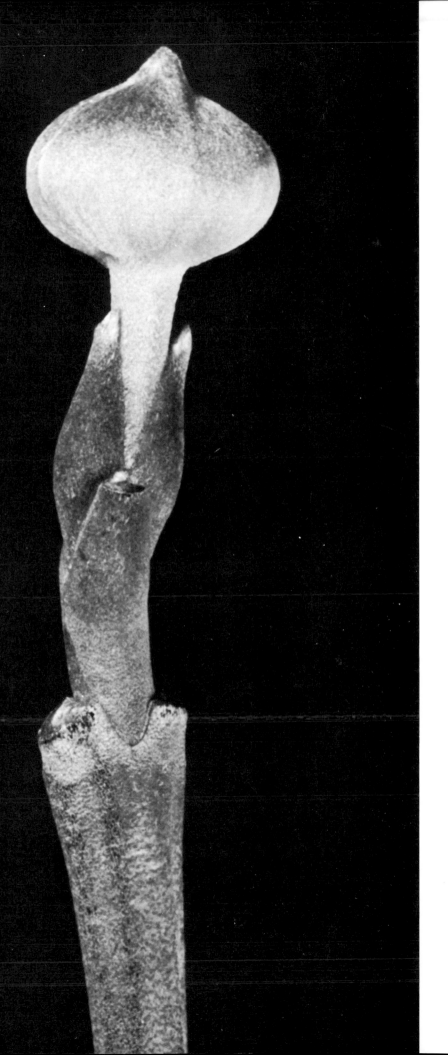

3

BUDS OF BLACK MAPLE, X 20

Acer nigrum Michx.

The black maple is similar to the sugar maple, but the buds of the former are stouter and more hairy. The lens-shaped patches, called *lenticels,* allow air to pass through the outer layers, and are usually found on all twigs. Each bud may develop into a branch so you can see from the paired buds that in the maples, branching (as well as leaf arrangement) is opposite.

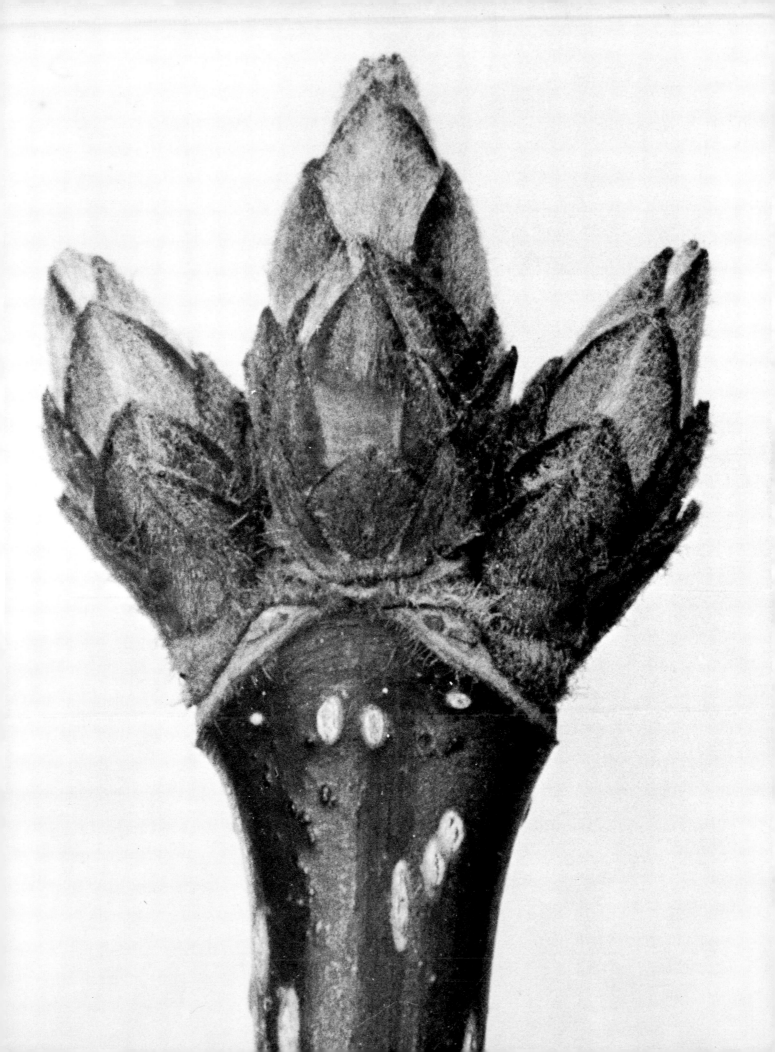

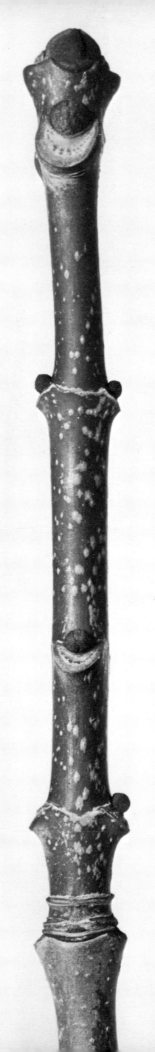

WHITE ASH TWIGS, X 3
Fraxinus americana L.
The difference in the growth rate of two twigs growing near each other is often remarkable. As the buds open in the spring, the scales curl back and fall off, leaving narrow scars around the twig. Each group of scars indicates the beginning of a year's new growth. The twig on the left grew near the outside of the crown where it got plenty of light; the seven-year-old dwarf on the right, looking like a totem pole, grew in the shade.

Opposite:
SPIRAL BUDS ON TWIGS OF BASSWOOD, ALDER, AND WILLOW, X 3
Tilia americana L., *Alnus rugosa* (Du Roi) Spreng., *Salix discolor* Muhl.
In determining the spiral fraction for the basswood twig at the left, one turn about the stem includes two buds; the resulting fraction is ½. For the alder, three buds are counted: ⅓. In the case of the willow, five buds are counted, but two complete turns are necessary to go from one starting bud to another. The fraction is ⅖.

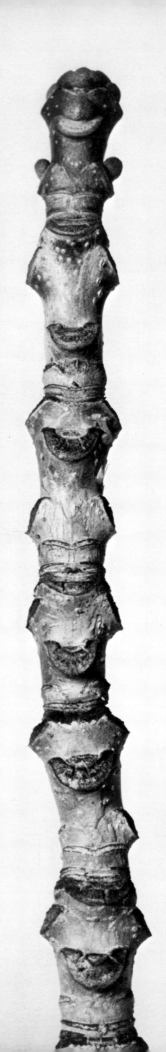

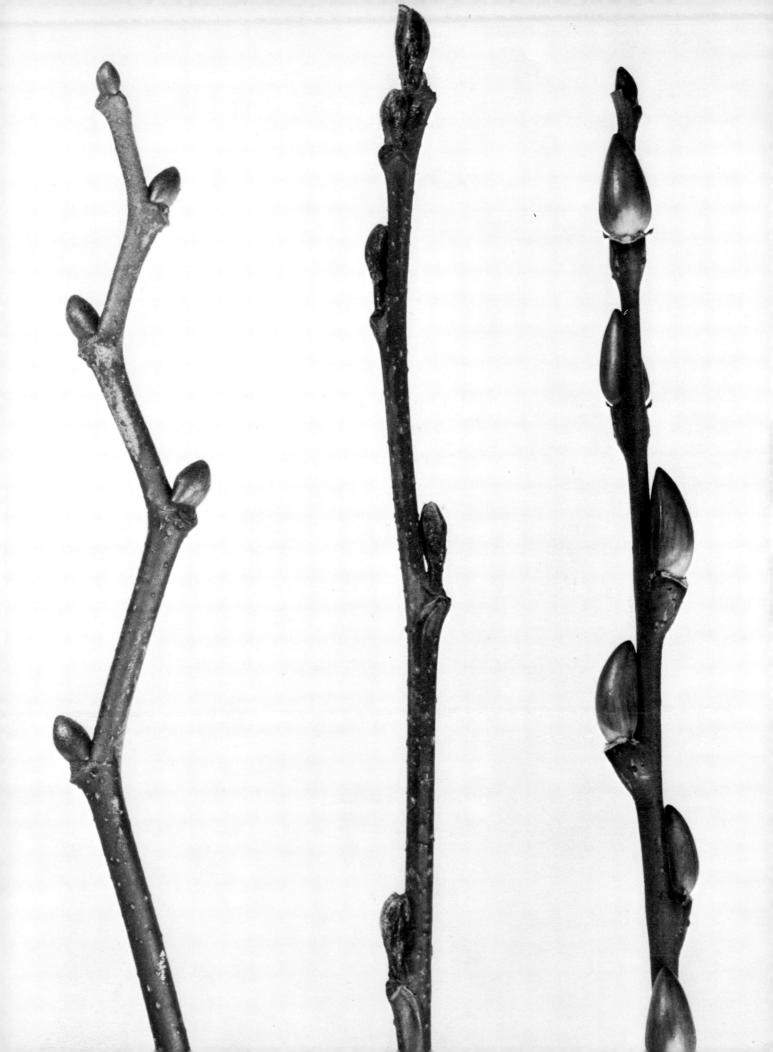

TWIGS OF BLACK WALNUT AND BUTTERNUT, X 5
Juglans nigra L., *Juglans cinerea* L.
These two American trees are well-known for both their fruit and beautiful cabinet wood. In the walnuts shown here, the bundle scars are in horseshoe-shaped groups, making each leaf scar look like a tiny horse's face.

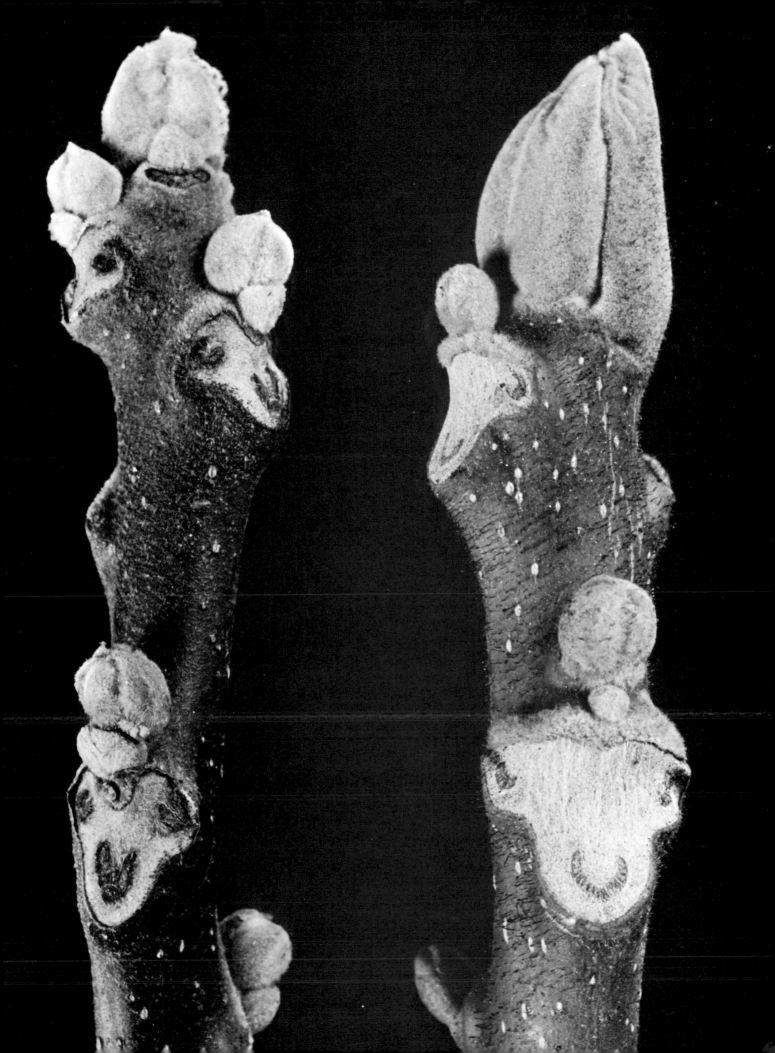

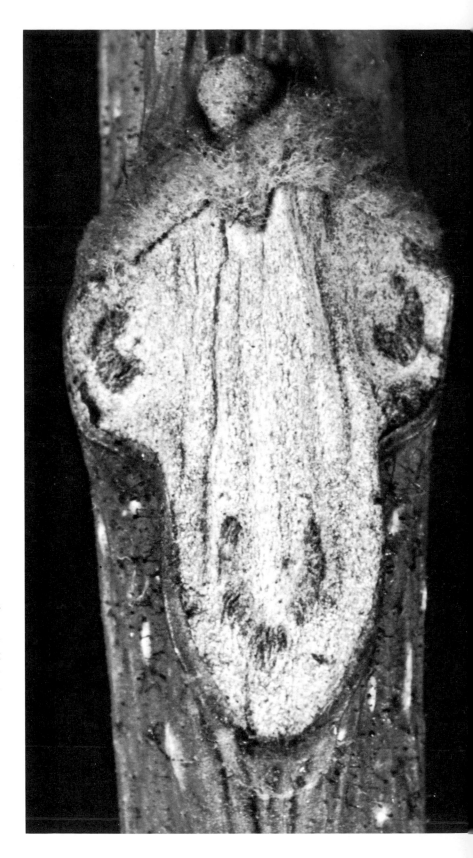

LEAF SCAR OF BUTTERNUT, X 10
Juglans cinerea L.
Notice that the face has hair over its "forehead." This differentiates it from the black walnut. The entire surface of the leaf scar is covered by a corky layer that prevents evaporation of water from the twig. This is a general feature of twigs and leaf scars.

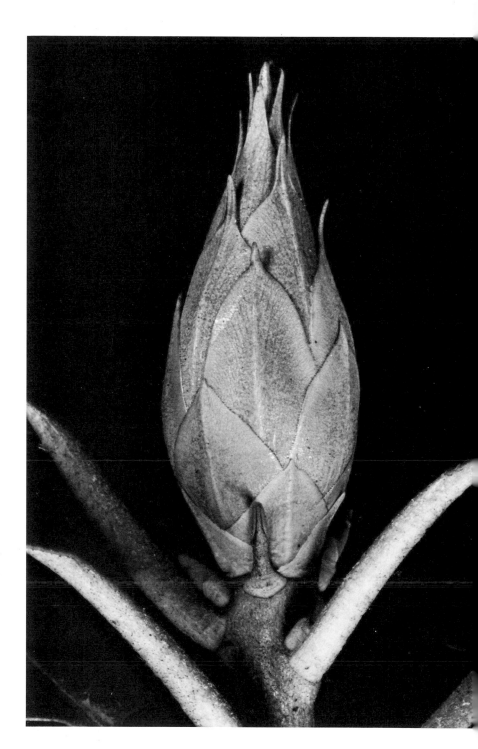

RHODODENDRON BUD, X 3
Rhododendron maximum L.
The flower bud shown here is much larger than a leaf bud. By counting flower buds the previous summer you can estimate the amount of flowering for the next spring.

OPENING BUDS OF LILAC, X 8
Syringa vulgaris L.
The opening green bud scales of the lilacs are among the first signs of spring.
From day to day the inner scales look more and more like leaves as they
expand. These bud scales seem to have evolved from blades of the lilac leaves.

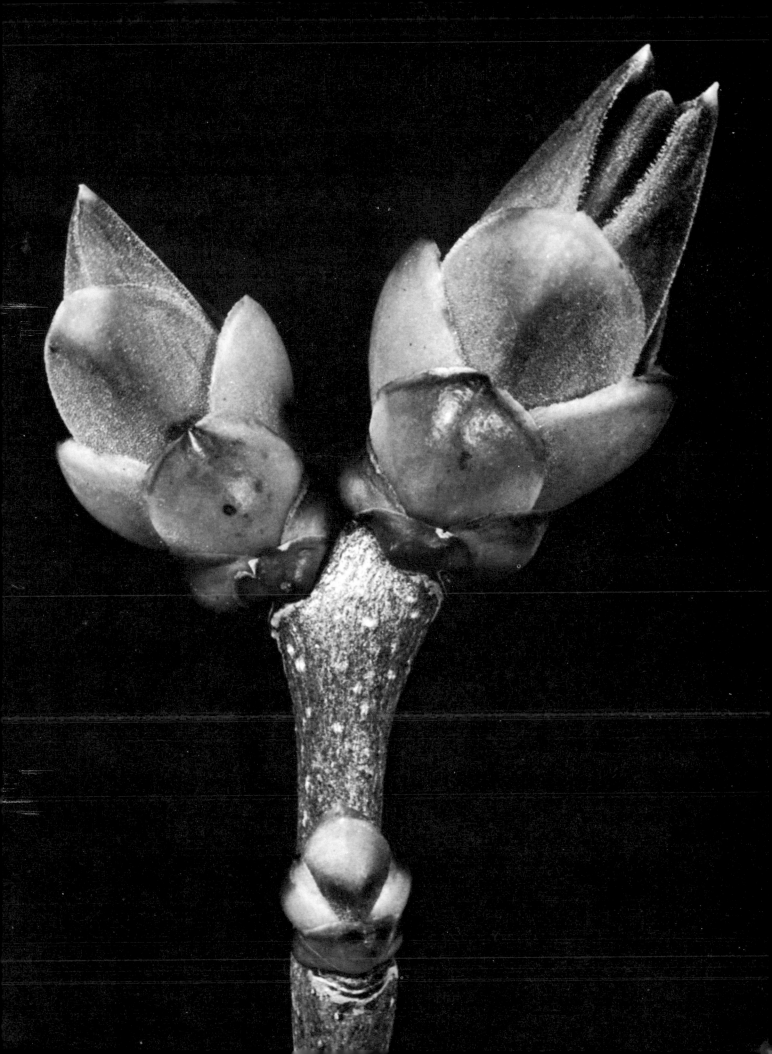

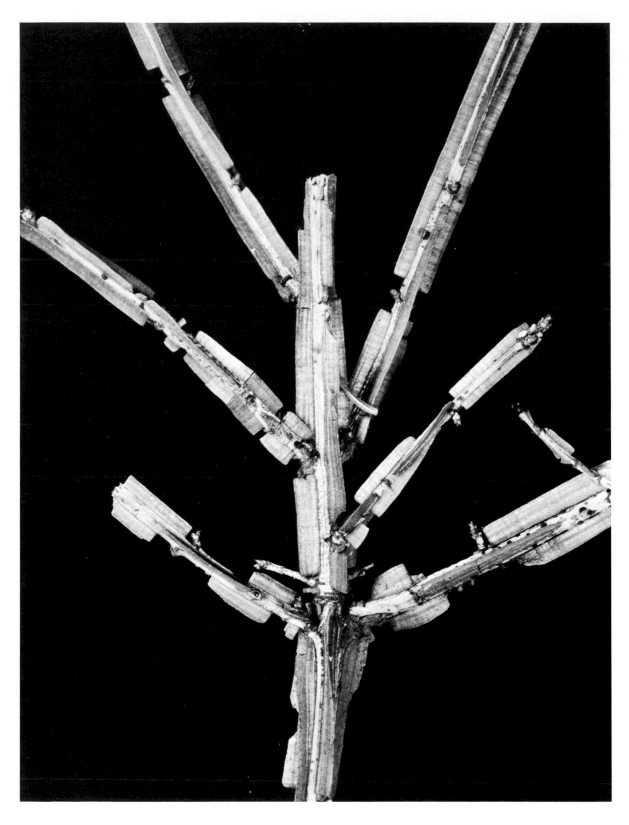

CORKY TWIGS OF WINGED EUONYMUS (SPINDLE-TREE), X 1
Euonymus alatus (Thunb.) Sieb.
In this species the twigs have a wide thin corky wing on each side particularly
conspicuous in winter when the shrub is bare of leaves. Another species in
this group is called burning-bush, because of its red autumn foliage.

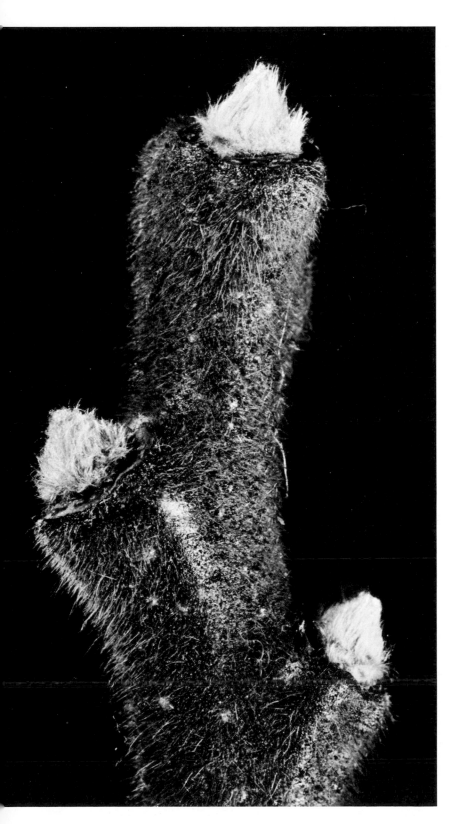

TWIG OF STAGHORN SUMAC, X 4
Rhus typhina L.
So-called because the bare winter branchlets resemble a stag's horns in the velvet. We think that the dense hair cuts down evaporation from a plant. This small tree is common on dry hillsides, but, weedlike, it is also found just about everywhere else. The somewhat yellow-brown heartwood has beautiful grain and figure, making it useful for lathe-turned art objects and for wood inlays.

15

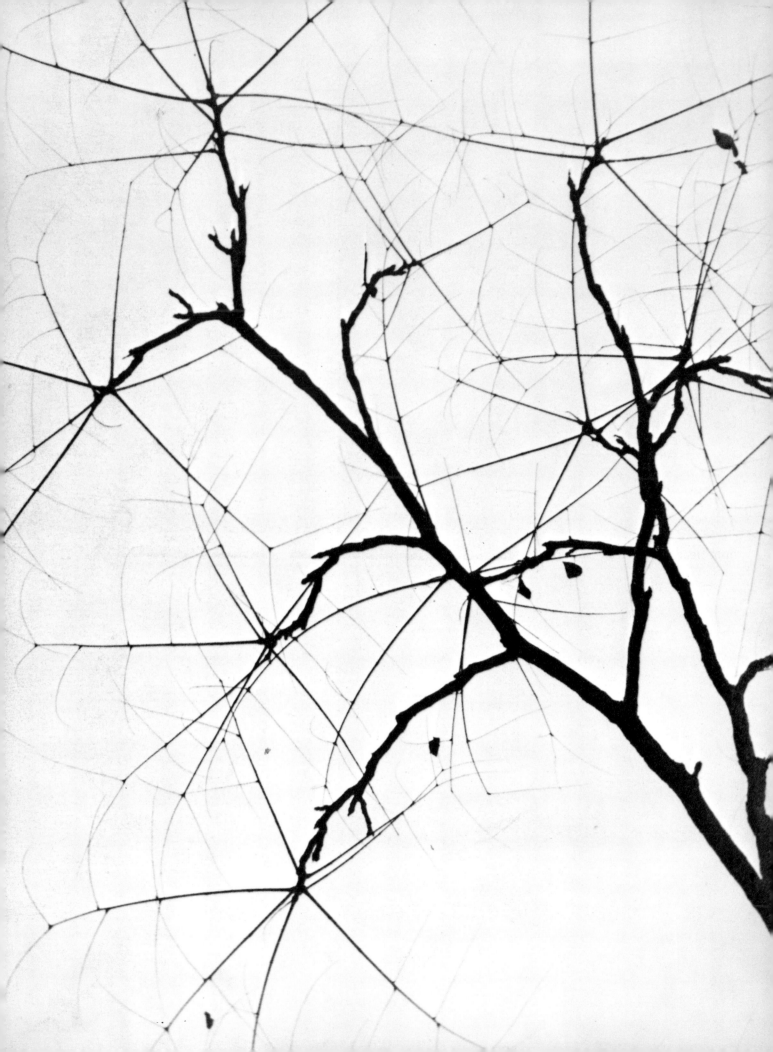

Opposite:
KENTUCKY COFFEE TREE, X ¼
Gymnocladus dioicus
(L.) K. Koch

The name of this legume is misleading. It is said that the early pioneers tried using the beans for coffee, but a bitter brew resulted. The photo shows the double leaf framework, visible only a few days each year in the autumn. The leafstalks may be nearly three feet long and overlapped, give a spiderweb appearance to the tree tops. A few of the little leaf blades can still be seen—there can be as many as 100 per stalk. They fall first, leaving the framework that bore them. This too soon falls.

TWIGS OF FIR AND SPRUCE,
X 10
Abies sp. and *Picea* sp.

One of the best ways to distinguish firs from spruces is by the bare twigs from which the leaves or needles have fallen. In the firs, including the balsam fir, a circular scar marks the place of leaf attachment. Spruce needles grow from small peglike projections of the twig itself.

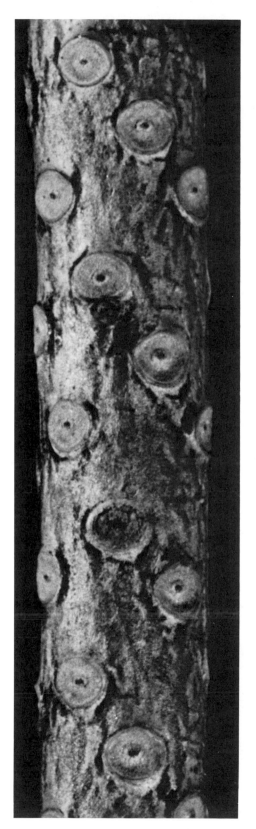

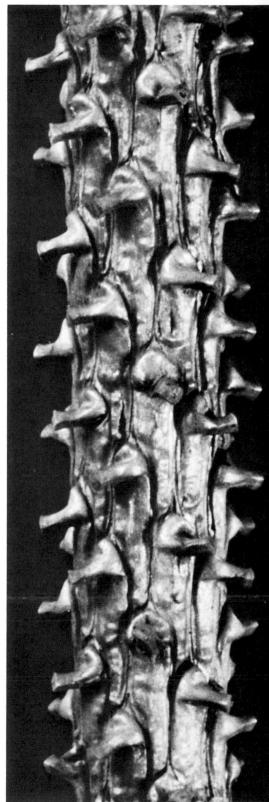

17

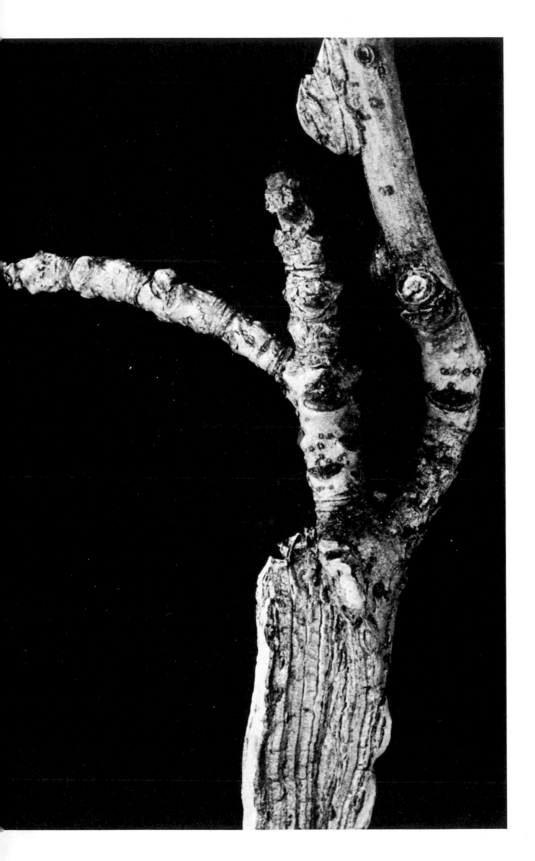

SWEETGUM TWIG, X 2
Liquidambar styraciflua L.
The sweetgum tree often has corky ridges on its twigs. Sometimes growth from the terminal bud of a tree becomes dwarfed, and a lateral bud replaces it. The contortions and markings of the twigs often suggest fanciful creatures to the imagination.

Opposite:
PORT-ORFORD-CEDAR, X 10
Chamaecyparis lawsoniana
(A. Murr.) Parl.
The fanlike branchlets of this large Pacific Coast tree bear innumerable tiny, paired, scale-like leaves. Some viewers find in the white markings on the leaves the cross of St. Andrew.

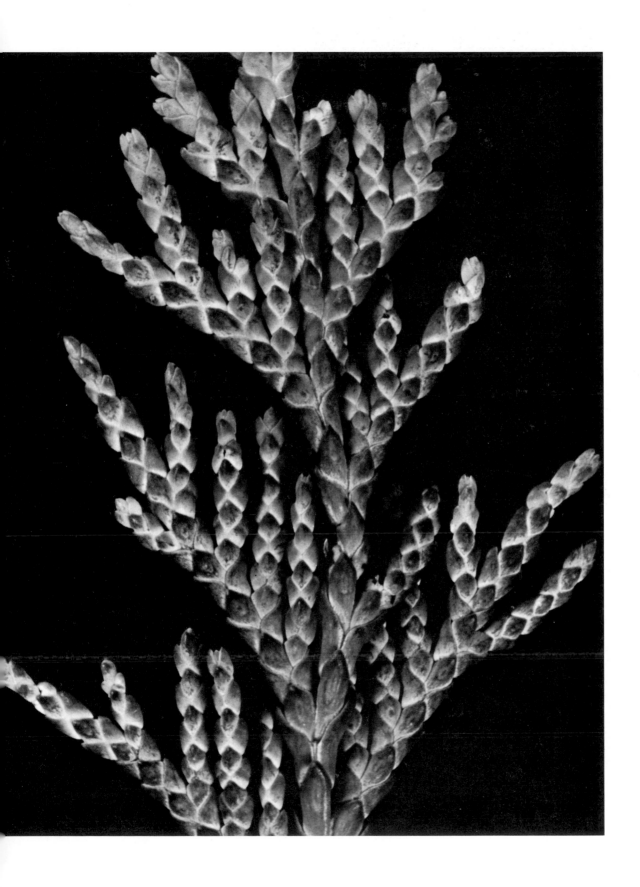

WHISTLING-PINE
FOLIAGE, X 4
Casuarina equisetifolia L.
Actually belonging to the broad-leaved group of trees, the name may come from the sound of the wind sweeping through the tree's crown of slender branches. The leaves are nothing more than tiny scales, and the branches themselves are green and synthesize food sugars for the tree. Whistling-pine comes from Australia and has been widely planted throughout the warmer parts of the world.

Opposite:
OPENING BUD OF
AMERICAN BEECH, X 4
Fagus grandifolia Ehrh.
Some of the most beautiful patterns in plants are displayed by leaves as they emerge from the buds. Buds never "burst," however; they open slowly over periods of hours or days. By speeding up growth from 500 to 5,000 times with a time-lapse camera some remarkable motion picture footage has been produced of opening buds.

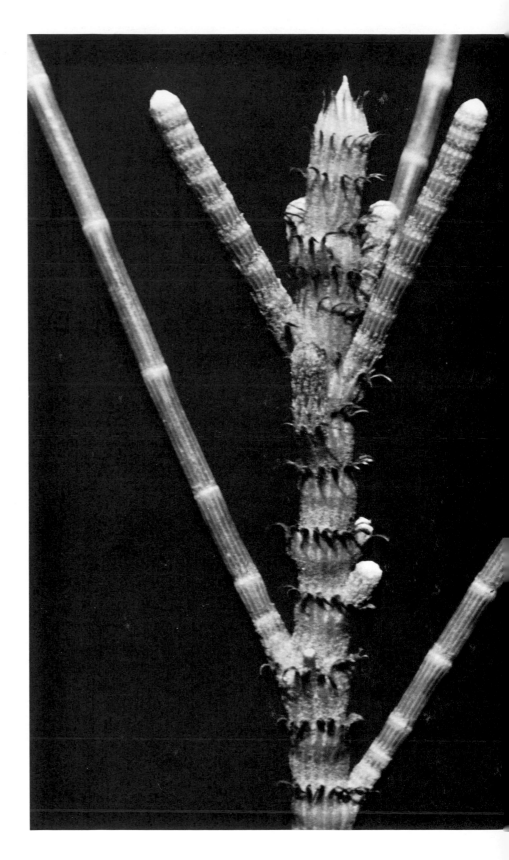

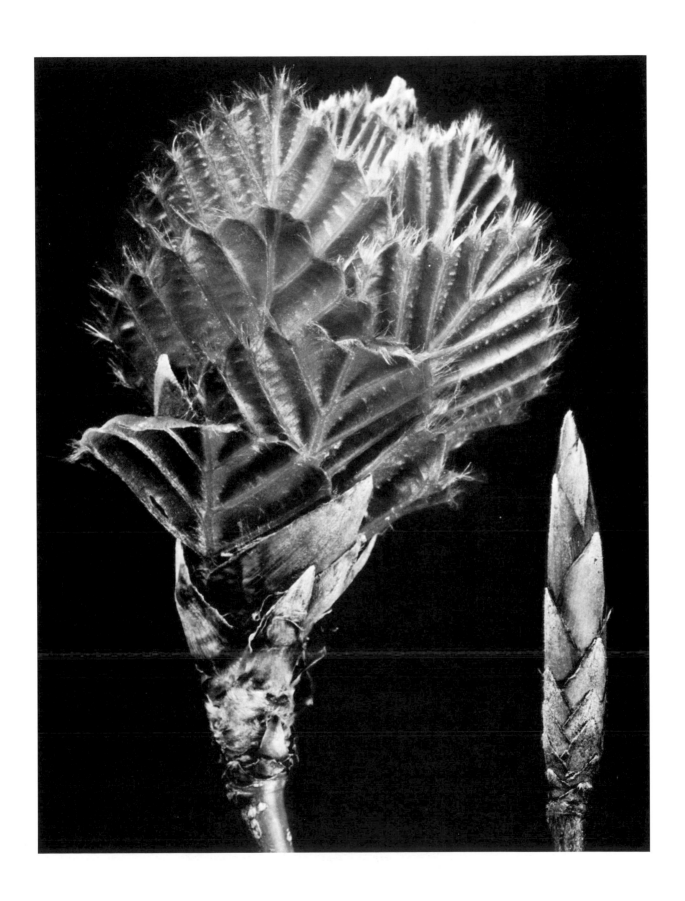

DAWN REDWOOD FOLIAGE, X 3
Metasequoia glyptostroboides Hu and Cheng
The dawn redwood is perhaps the most exciting botanical discovery of this century. Found in 1941 in a remote province in China, it was supposed to have become extinct twenty million years ago. Seeds were brought out, and the tree was established in several countries. It can be easily propagated by cuttings and is now available from many sources. In autumn, the leaves turn a beautiful gold color and fall off, leaving the tree bare all winter.

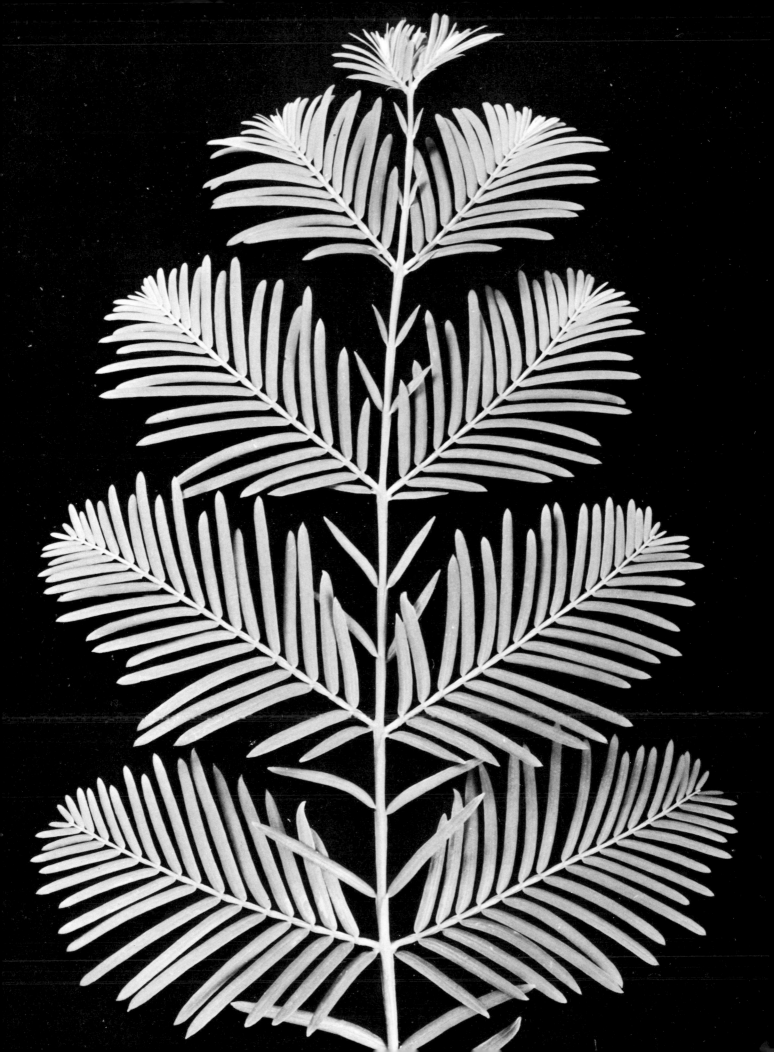

LEAVES OF TAMARACK, X 7

Larix laricina (Du Roi) K. Koch

The larches, including this one, are among the few conifers which lose their leaves in autumn. The leaves on the first year's growth are borne singly in spirals. By the end of the season, a number of stubby side buds develop and from these the leaves grow for several years thereafter in compact false whorls as shown.

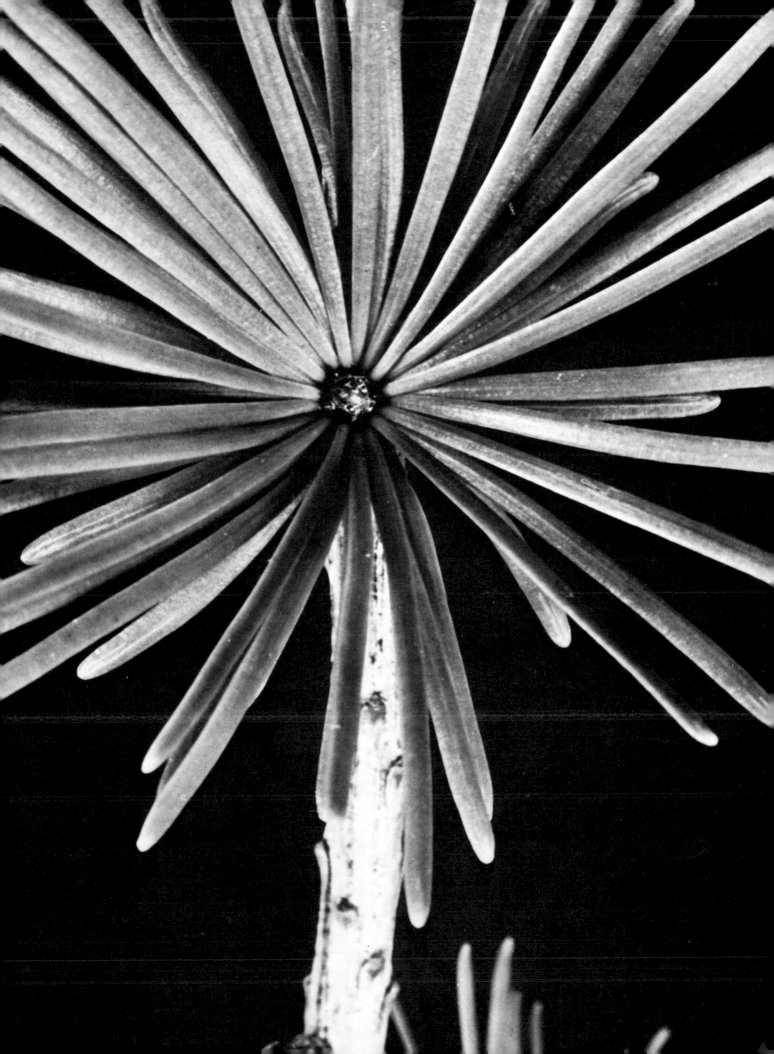

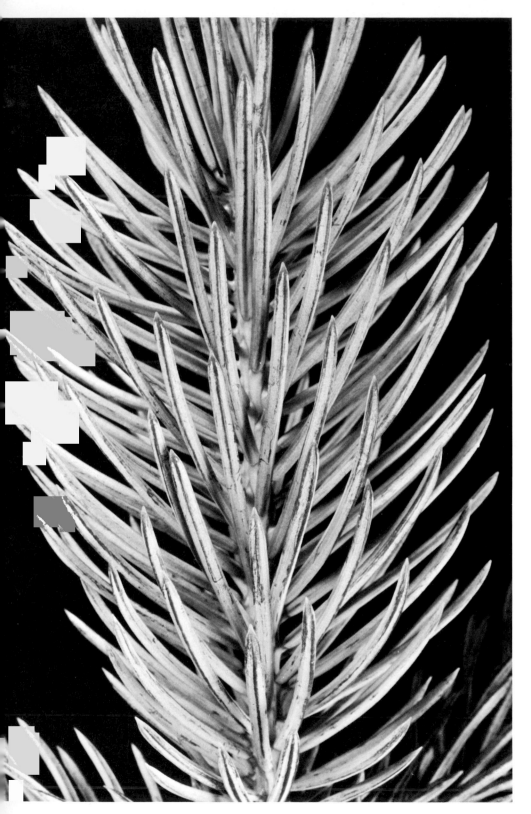

BLUE SPRUCE NEEDLES, X 4
Picea pungens Engelm.
Great variation can be found
in the color of individual trees
of the Colorado blue spruce.
Seeds from a single forest tree
may produce offspring varying
in color from many shades of
green to silver.

Opposite:
NEEDLES OF WHITE PINE, X 4
Pinus strobus L.
Pines are recognized by their
needles, which occur in
bundles. The five needles of
the eastern white pine together
form a cylinder. To the Iro-
quois Indian tribes, the five
needles bound together sym-
bolize the five nations in the
Great League.

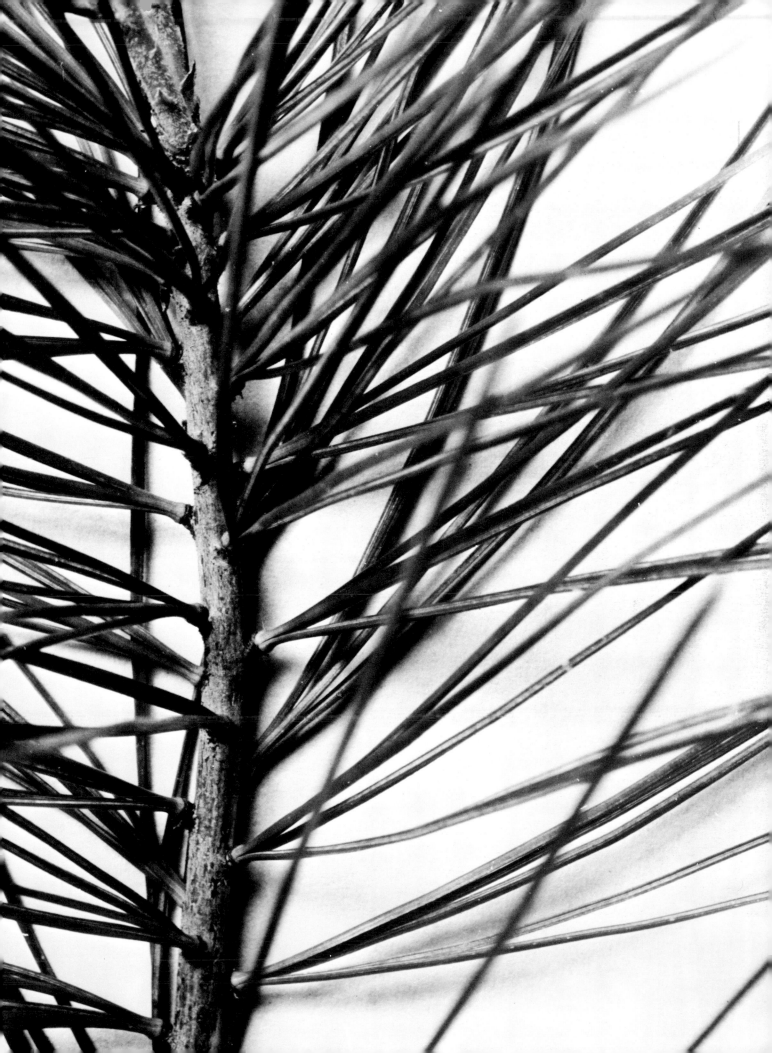

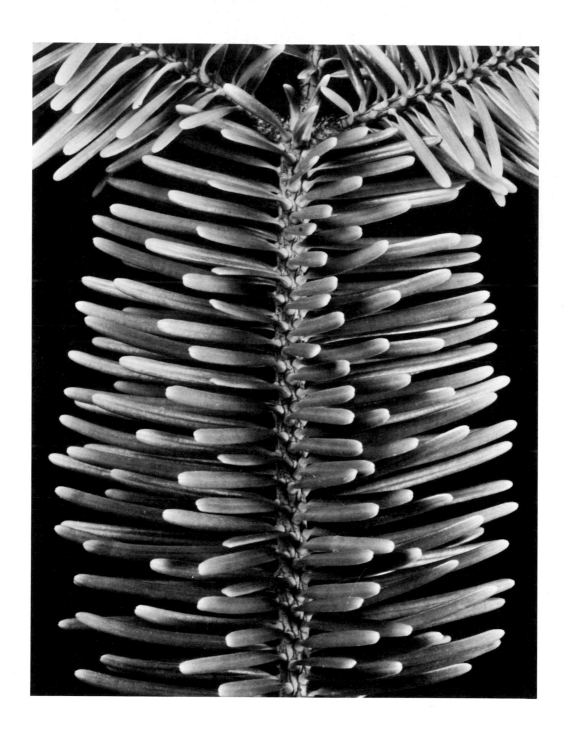

NIKKO FIR, X 3
Abies homolepis Sieb. and Zucc.
This Oriental species with its stiff, spirally arranged leaves is planted as an ornamental tree in the United States.

Opposite: CHINESE FAN PALM LEAF, X 1
Livistona chinensis R. Br.
Each leaf of this plant is a study in radial symmetry.

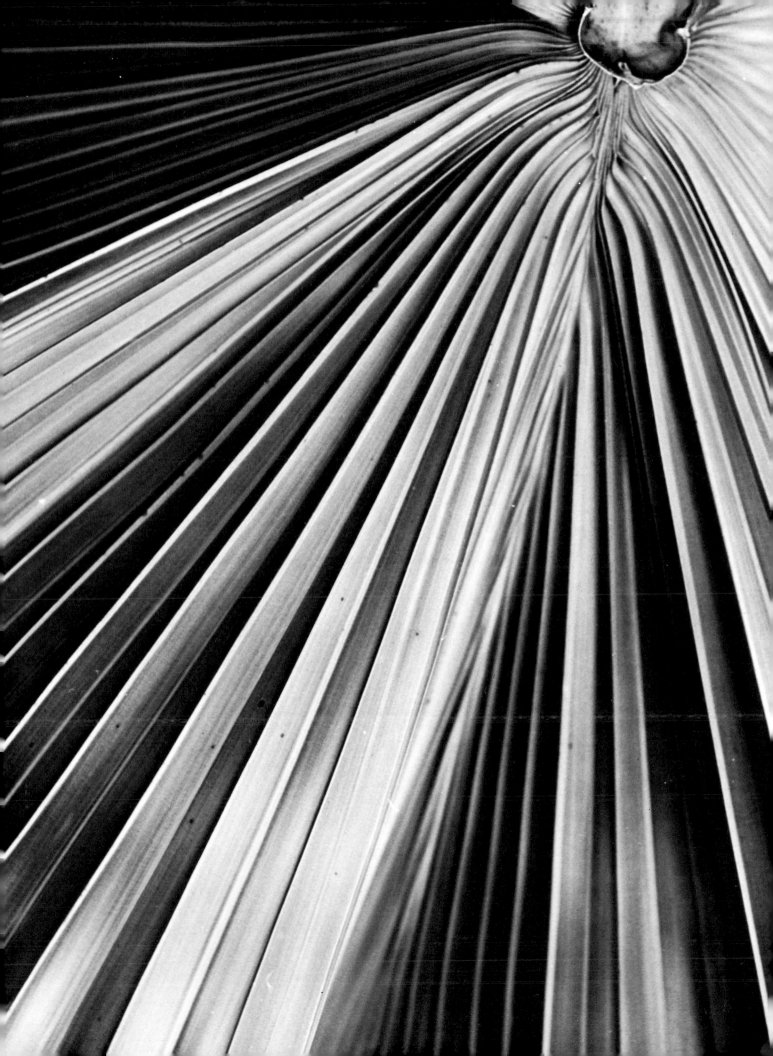

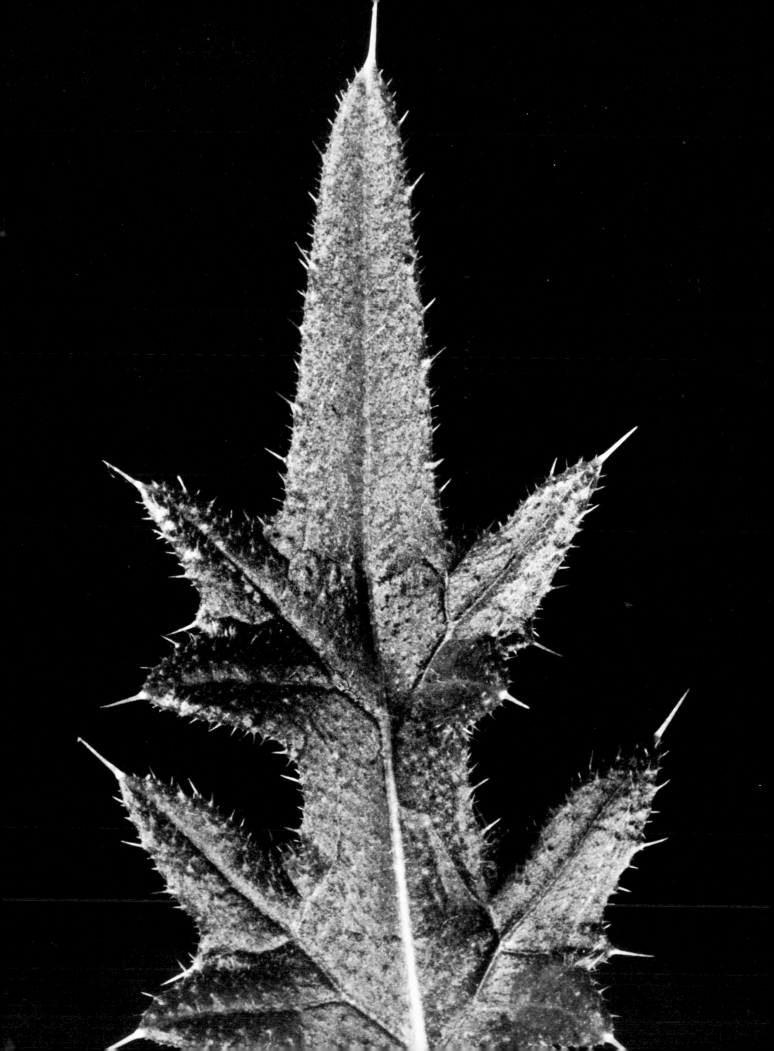

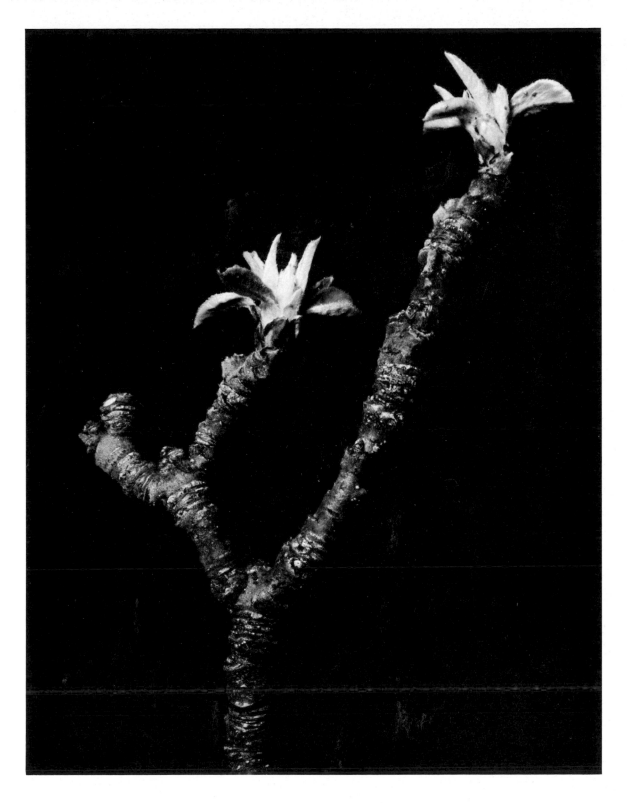

NEW LEAVES OF APPLE, X 2
Malus pumila Mill.
This shaded apple twig grew very slowly. By counting the transverse groups
of bud scale scars, you can calculate its approximate age.

Opposite: BULL THISTLE LEAF, X 1
Cirsium pumilum (Nutt.) Spreng.
Thistle leaves are well armed for defense.

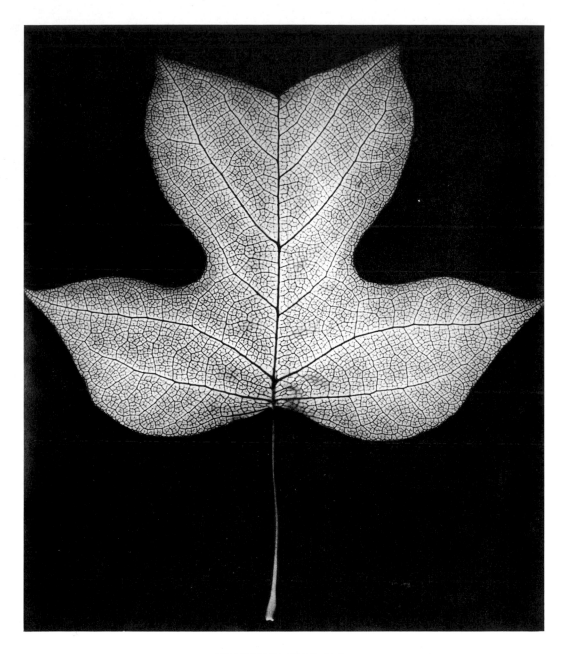

TULIPTREE LEAF, X 1
Liriodendron tulipifera L.
There are only two species of the *Liriodendron* in the world; one is in east-
ern China, and the other is an important timber tree of the eastern United
States. It is supposed that at one time, before the Rocky Mountains rose, the
two species were one, ranging across the Aleutian Bridge into Asia.

Opposite: VEIN PATTERN OF TULIPTREE LEAF, X 3
Liriodendron tulipifera L.
This is the first of several negative images (See Notes on Photographic Tech-
niques, p. xv) in which blacks and whites are reversed. Veins are the pipe
lines of a leaf. The smallest veinlet can be traced back to the central complex
or midrib of the leaf. Through veins a continuous supply of water and dis-
solved minerals flows into the leaf, and sugars and other food materials made
by the leaf are carried back into the stem and growing parts of the tree.

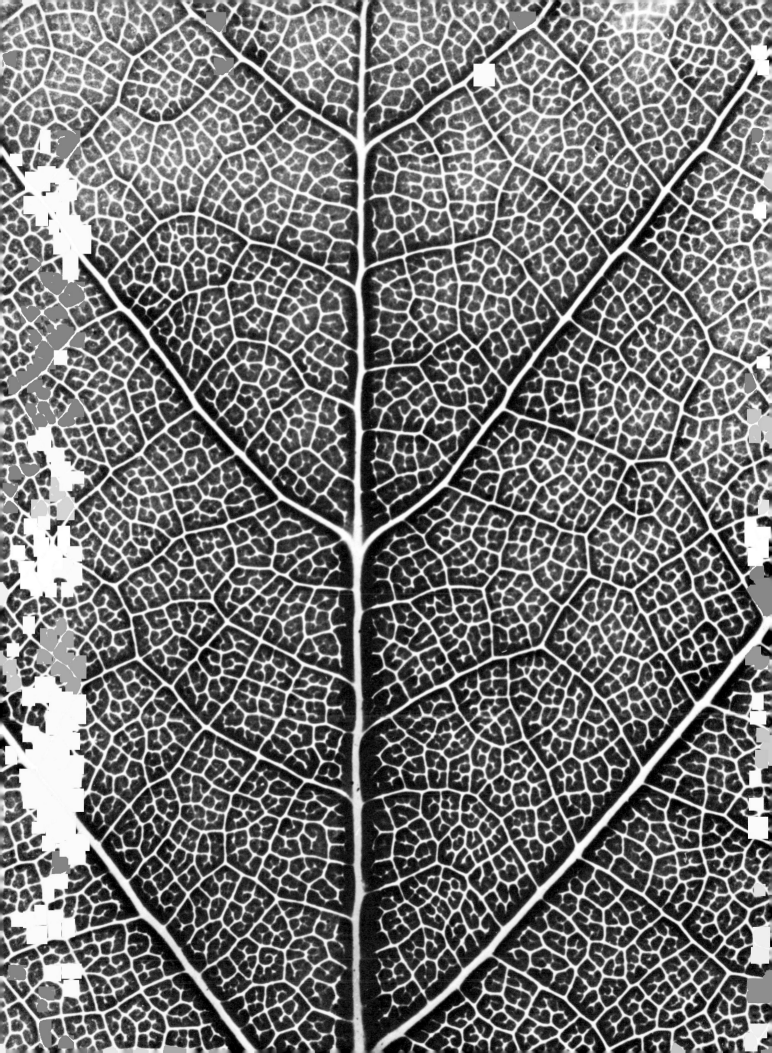

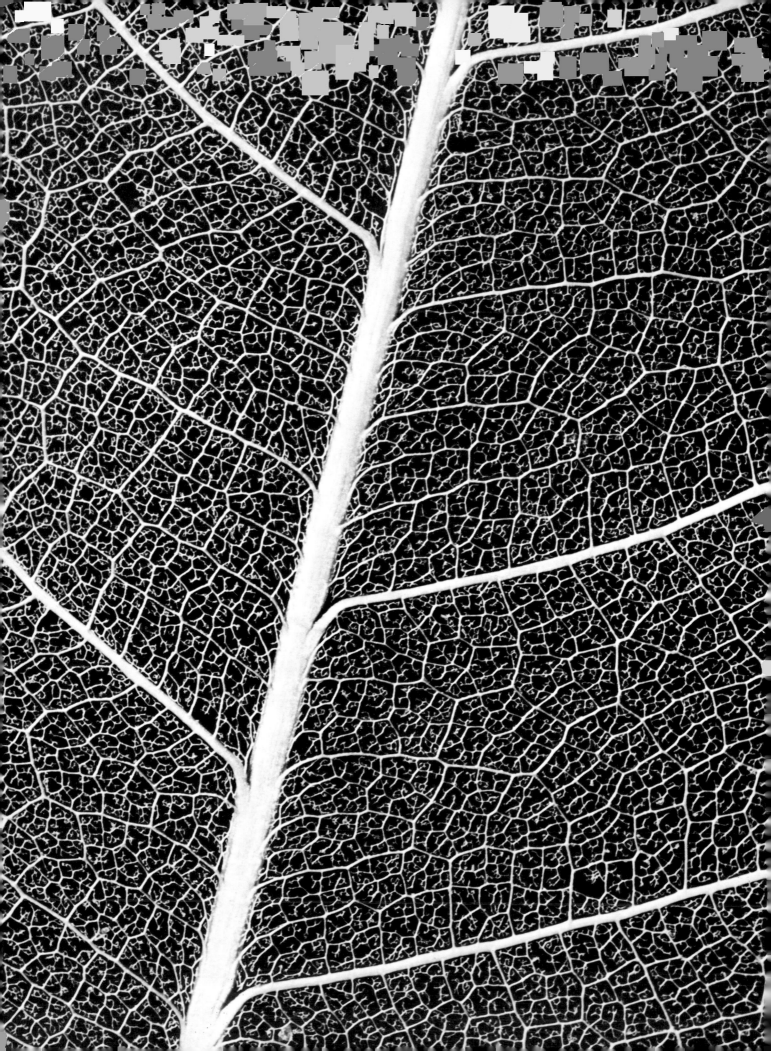

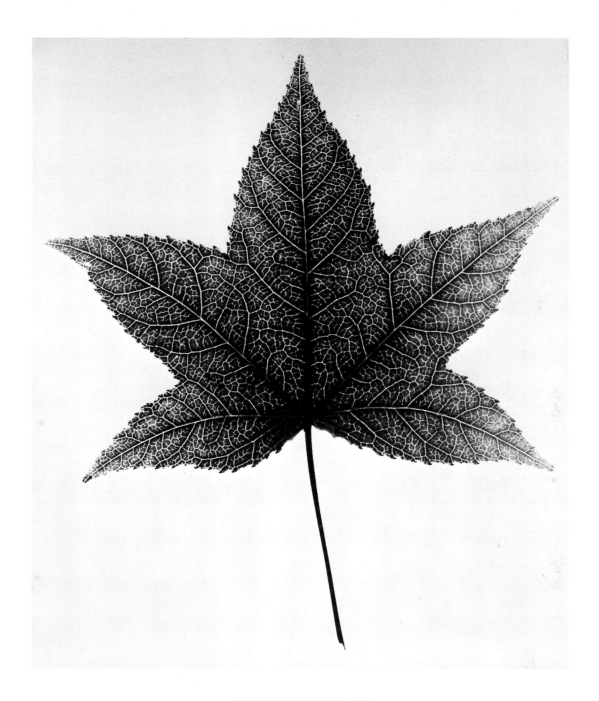

SWEETGUM LEAF, X 1
Liquidambar styraciflua L.
Sweetgum is an important southern veneer-producing tree; in the north, it is valued for its brilliant autumn leaves. When cuts are made in the bark, a balsamic resin exudes and hardens into droplets. Storax used in the making of perfume can be extracted from the resin.

Opposite: LEAF VEINS, X 4
Another negative image of a vein pattern, this one from South America. The magnolia-shaped leaves are soaked in mud until the live tissues are eaten away. Cleaned by washing, the leaf skeletons are sent to the U.S. where they are dyed different colors and sold in florists' shops.

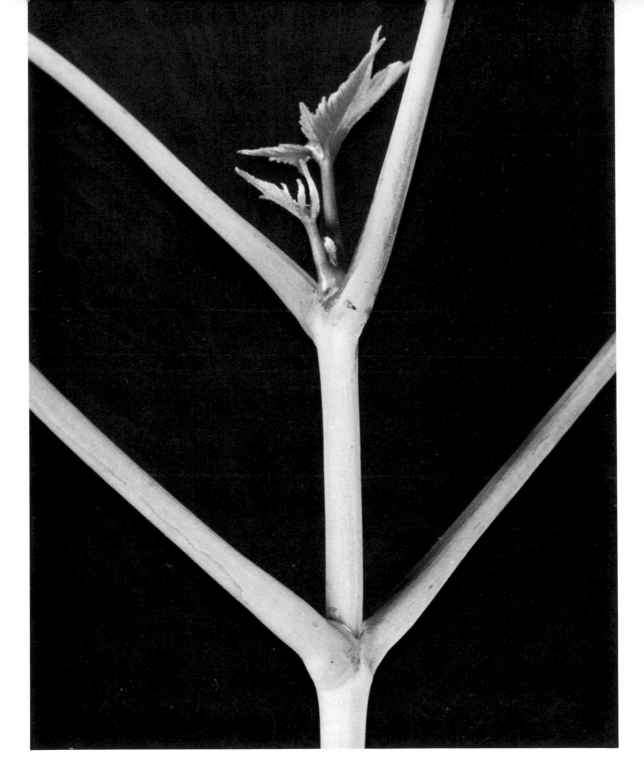

BOXELDER, X 3
Acer negundo L.
This is not an elder: it is a maple, but its leaves are not at all like the typical maple's single blade with radial veins. Boxelder has leaves with several leaflets. Here you see the long paired leaf stems of four leaves (the leaflets are outside the photo). The next pair is emerging at the top.

Opposite: PARALLEL VEIN PATTERN OF A CORN LEAF, X 3
Zea mays L.
Seed plants are divided into two broad groups. Monocotyledons such as corn, grasses, and many others, have leaves with parallel veins; the other group, dicotyledons, have leaves with branching veins which form a complex network. (See tuliptree, p. 32, and sweetgum, p. 35.)

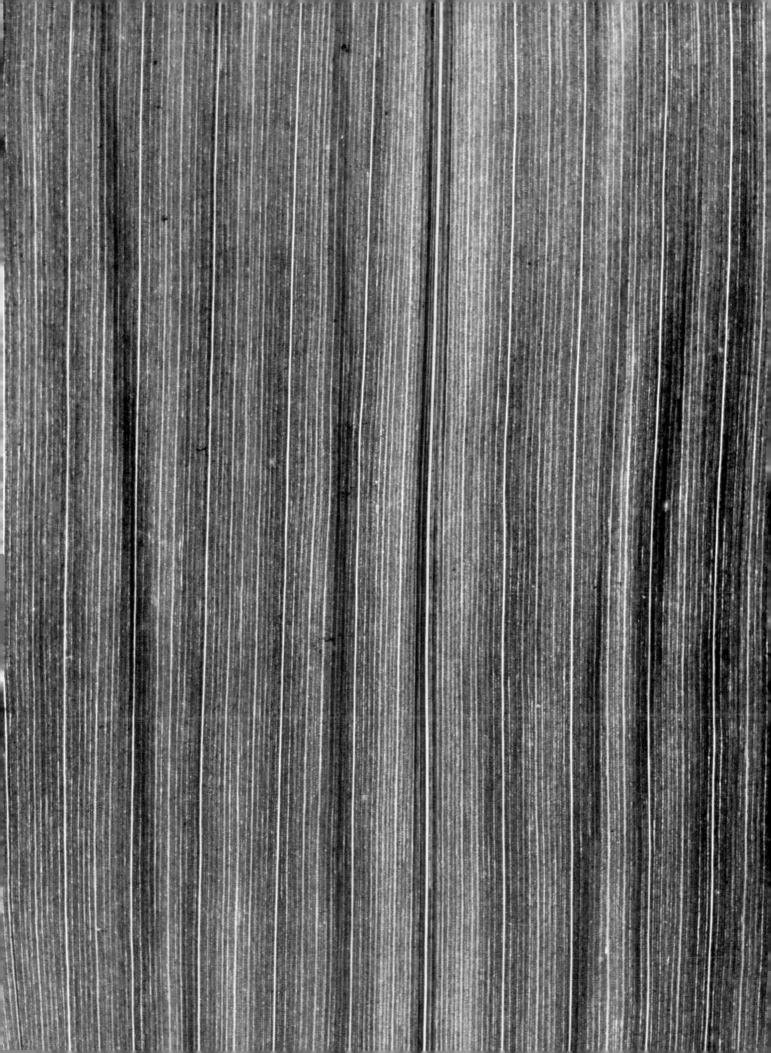

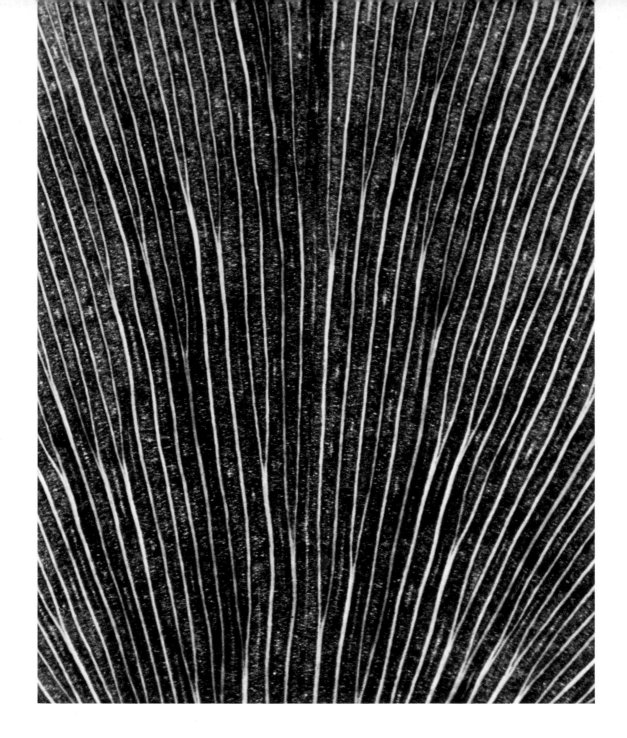

VEIN PATTERN OF A GINKGO LEAF, X 8
Ginkgo biloba L.

This is the vein pattern of one of the most ancient trees in the world. Each vein always branches into two others, and they in turn divide in the same way. The ginkgo with its fan-shaped leaves belongs to the primitive gymnosperms which also include the conifers.

Opposite: WAYFARING-TREE LEAF VEINS, X 3
Viburnum lantana L.

This is another example of net venation; the pattern is reinforced by the heavy covering of hair (pubescence) on the undersurface of the leaf.

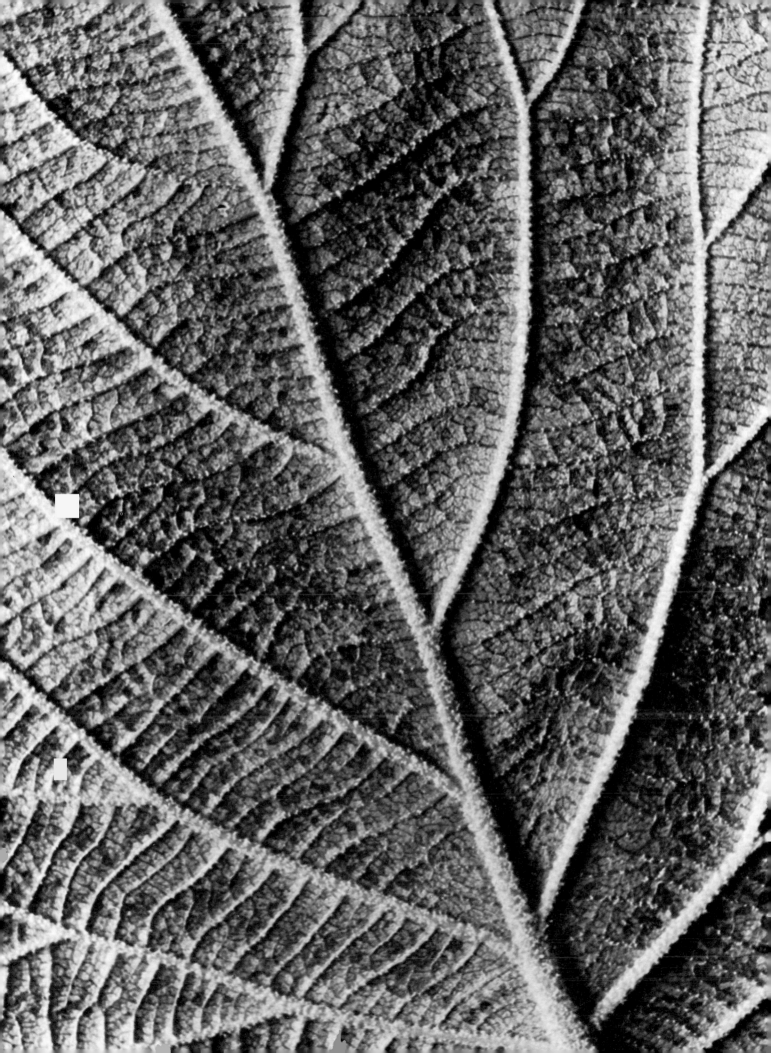

SKELETONIZED BEAN LEAF, X 5
Phaseolus sp.
Compared to the soft green tissues between them, the veins of leaves are woody, consisting of water-conducting tubes. Leaf-eating insects tend to eat out the softer tissues and leave the veins relatively untouched.

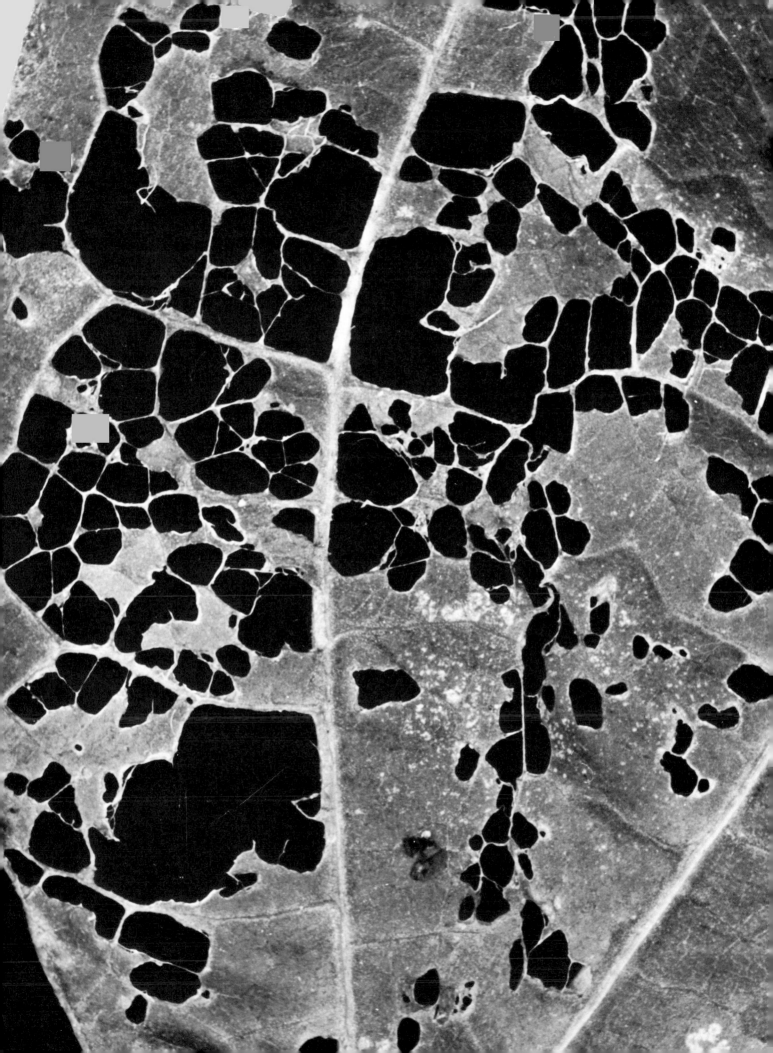

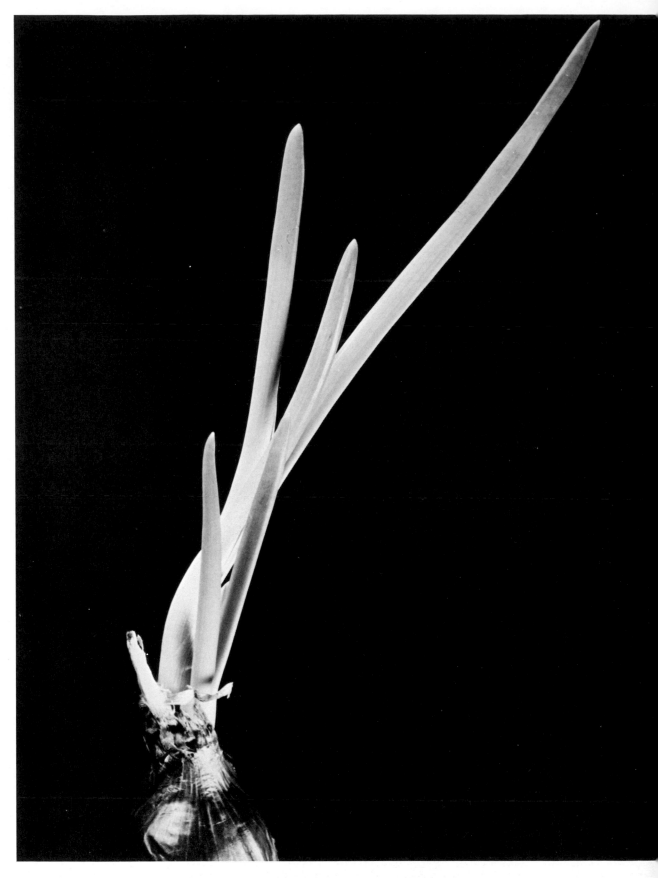

ONION AND BEAN SEEDLINGS GROWING TOWARD LIGHT, X 2
Allium sp. and *Phaseolus* sp.

Indoor plants reach toward a window or other source of light. Outdoors on a very hot sunny day, the leaves of beans and some other plants slowly turn and present their edges to the sun. Later in the afternoon when sunlight is less intense, the leaves move back to a position facing the sky.

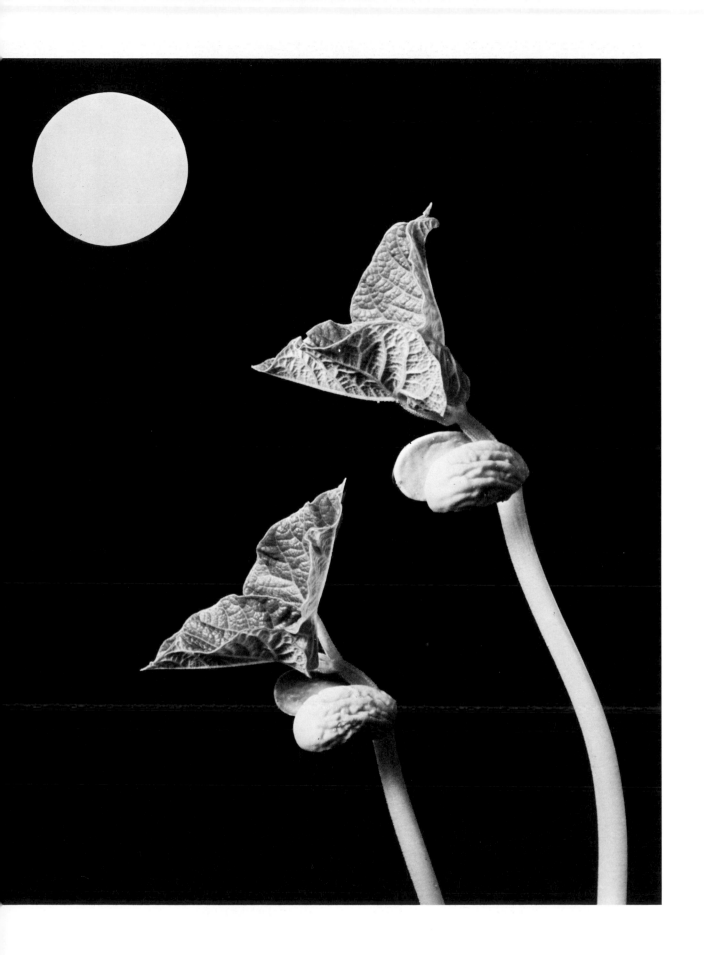

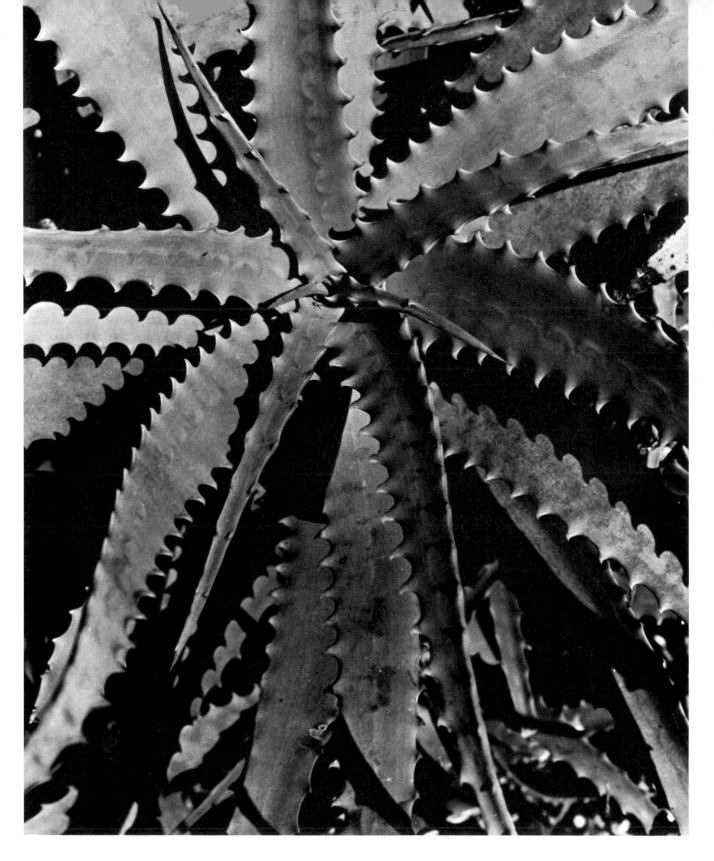

ALOE, X 1
Aloe sp.
These plants of the lily family are widely distributed in dry parts of the earth, especially in Southern Africa. They are now widely planted throughout the warmer parts of the world as ornamentals and in cooler regions as house plants.

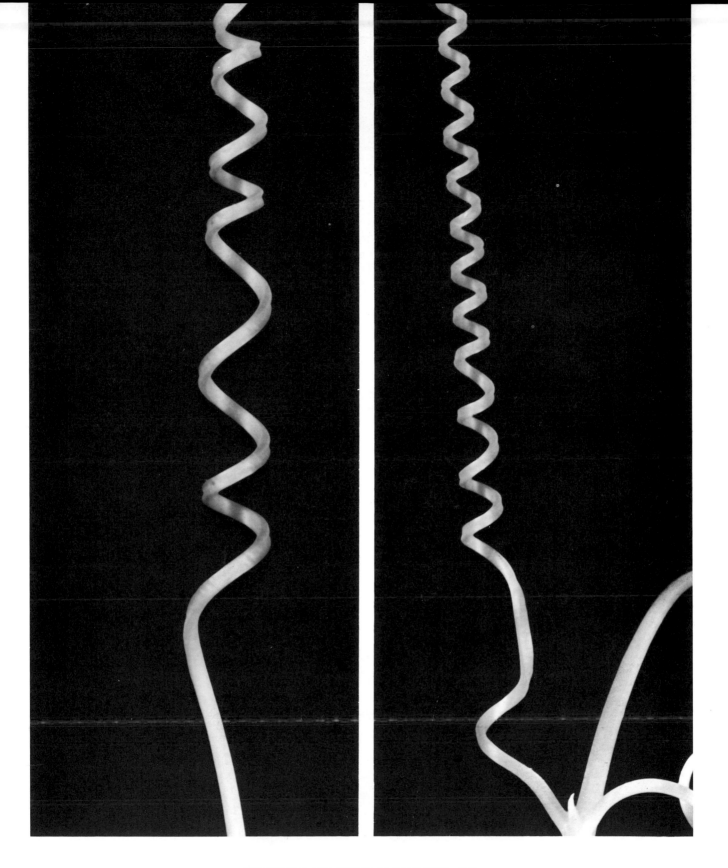

TENDRILS OF WILD CUCUMBER, X 5
Echinocystis lobata (Michx.) T. and G.
Some of the most beautiful spirals of nature are displayed by the tendrils of certain plants. The long slender tendrils of this wild cucumber make sweeping circular motions, and when the sensitive tip touches a support it encircles it in about one minute. The tendril then shortens itself by forming a spiral and draws the plant over to the support.

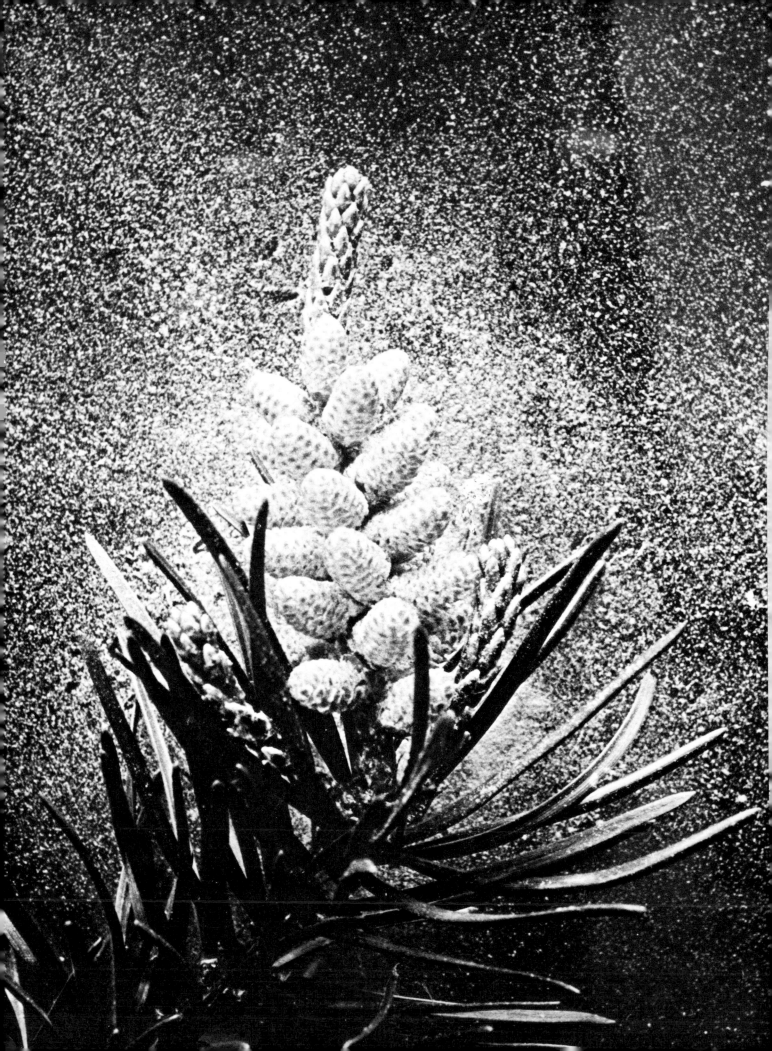

Opposite: POLLEN GALAXY: MALE CONES
OF JACK PINE, X 3
Pinus banksiana Lamb.
The amount of pollen discharged from even
a single cluster of cones must be numbered in
the billions. A light breeze is enough to carry
pollen a long way through a forest, and the
chances of pollen from the male cones of a
tree reaching the female cones of another tree
are very good.

FEMALE CONES OF A PINE, X 3
Pinus sp.
Though the young cones may be bright red
they are too small to be seen easily. Little
growth occurs the first season. The next spring
the cones in most species turn over and be-
come pendent, and the rate of growth ac-
celerates. In the largest-coned pines, from less
than an inch, cones two feet long develop the
second season.

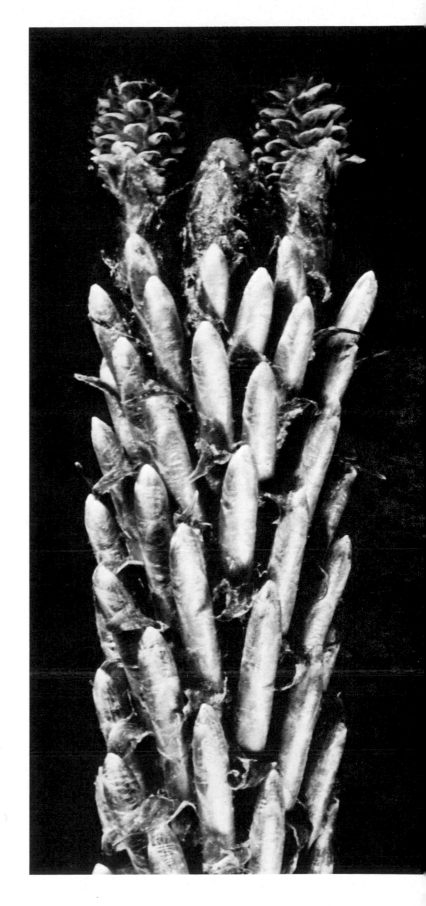

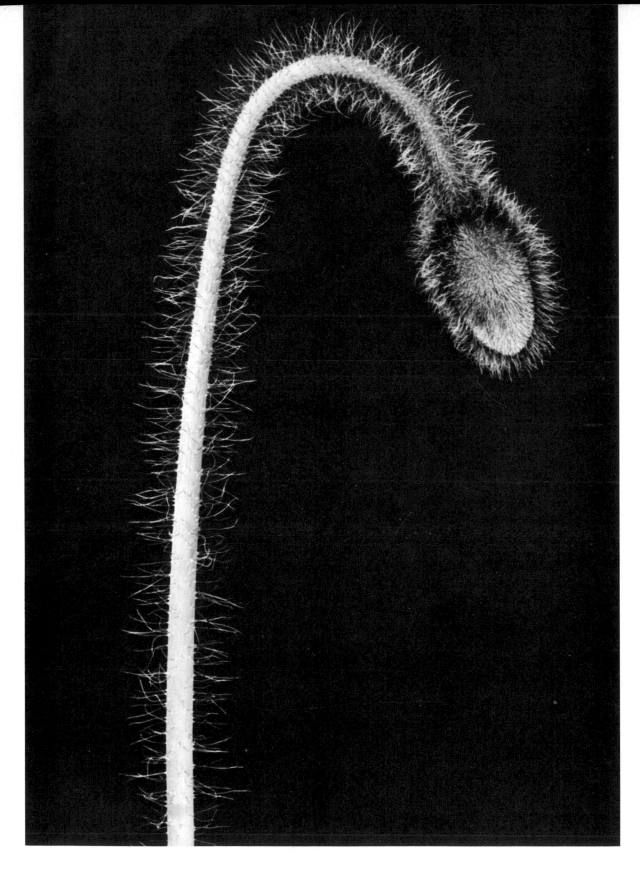

BUD OF ICELAND POPPY, X 6
Papaver nudicaule L.
These poppies are now widely planted in gardens throughout the cooler parts of the world. See also page 79.

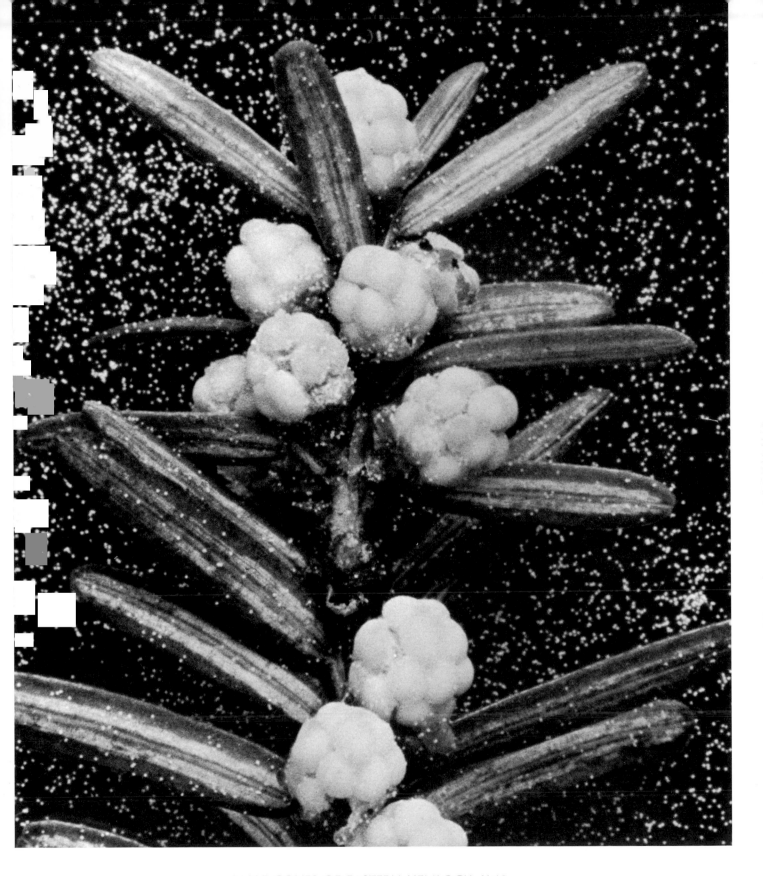

MALE CONES OF EASTERN HEMLOCK, X 10
Tsuga canadensis (L.) Carr.
The hemlocks are graceful, ornamental trees of moist, shady places. Hemlock tea brewed from the "needles" was used to treat the malnutritional disease, scurvy. The "poison-hemlock" mentioned in ancient times has no connection at all with this tree, but is a relatively rare herbaceous plant.

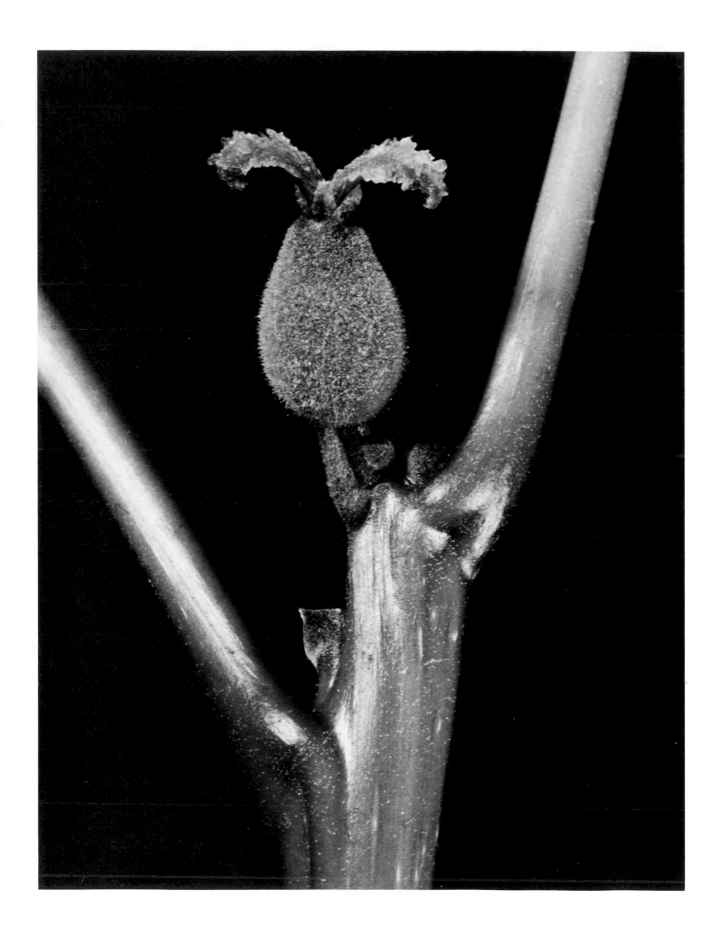

50

Opposite:
FEMALE FLOWER OF ENGLISH
WALNUT, X 8
Juglans regia L.
Because tree flowers are usually small and without showy or colorful petals, they go unseen. The large feathery stigma at the top of the walnut flower is adapted for trapping wind-borne pollen.

BACHELOR'S-BUTTON BUD, X 6
Centaurea sp.
Like the dandelion, this plant belongs to the vast composite group of plants in which each "flower" is a compact head of many flowers. The bud scales illustrate a spiral pattern.

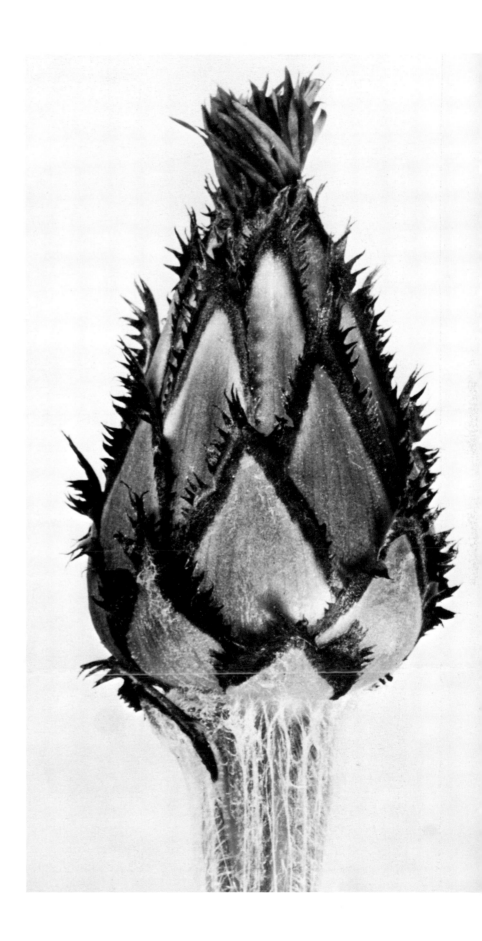

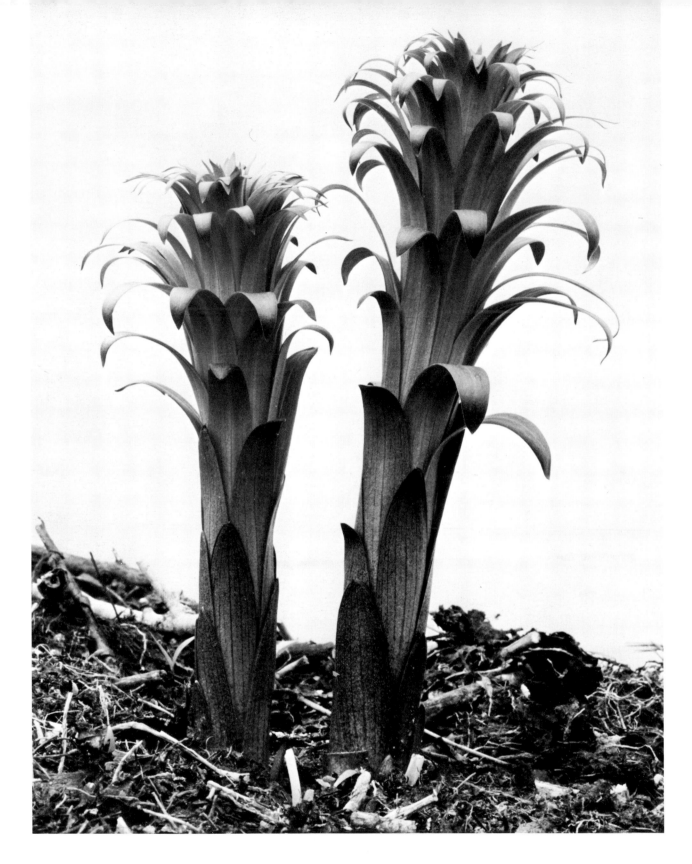

A GARDEN LILY, X 2

The twin stems bear spiral leaves that form another of nature's patterns. These stems of the Regal Lily grew to a height of seven feet, and one of them bore nineteen large yellow blossoms like the one opposite (X2 magnification).

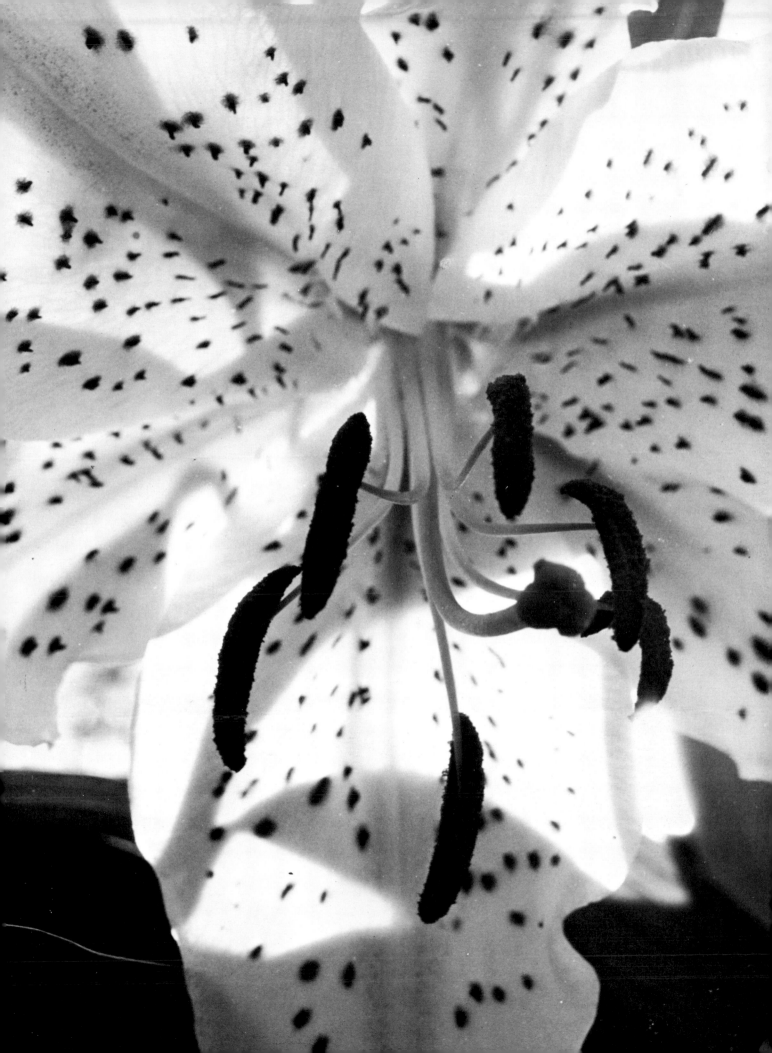

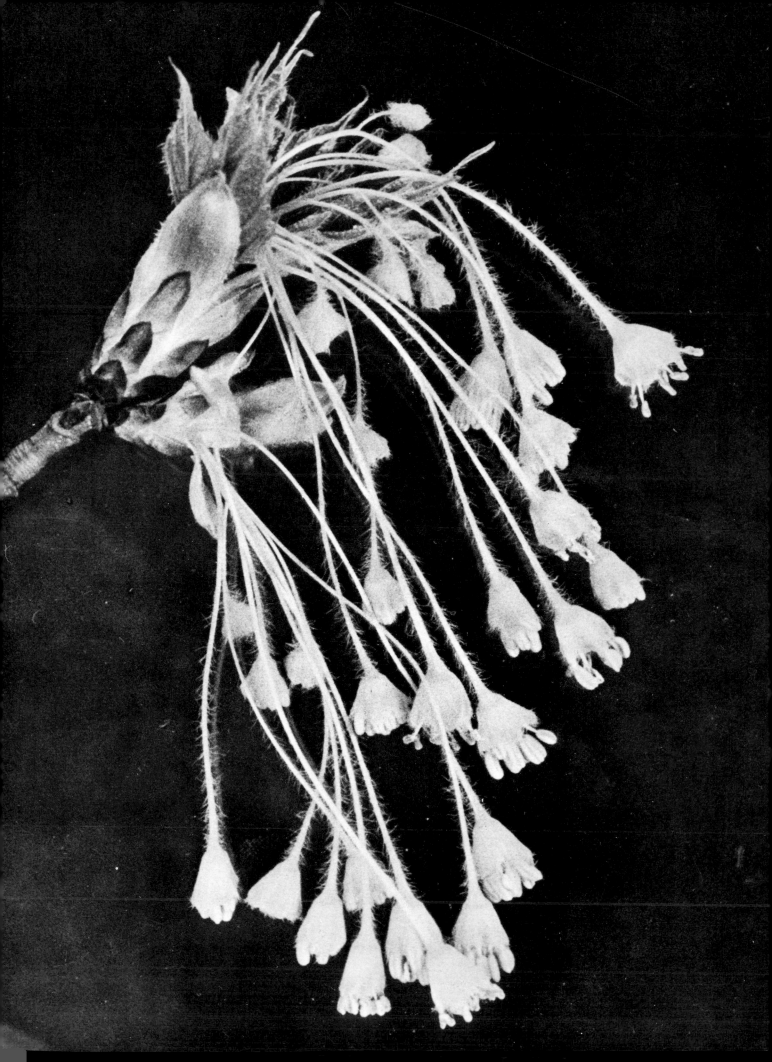

Opposite:
SUGAR MAPLE FLOWERS, X 3
Acer saccharum Marsh.
In some trees, flowers appear each spring, but in others they are borne at several-year intervals. This is the way of the sugar maple; when flowering does occur, a tree often bears so heavily that for a few days it seems, at a distance, to be covered with a yellow mist. Flowering lasts but a few days and the emerging leaves soon cover the tree with a new mantle of fresh green.

SINGLE FEMALE FLOWER OF A
WILLOW, X 40
Salix sp.
When one thinks of willows it is usually the furry catkins that are visualized. Each catkin consists of several hundred of these tiny flowers packed tightly together along a central axis; the males and females on separate trees.

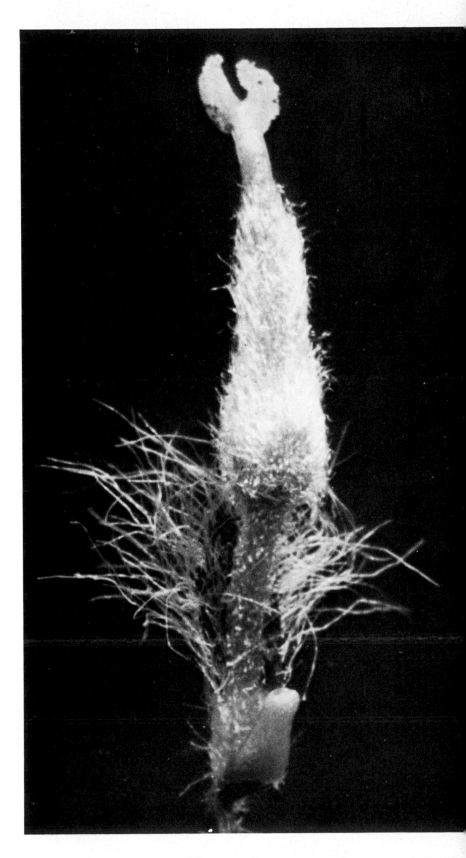

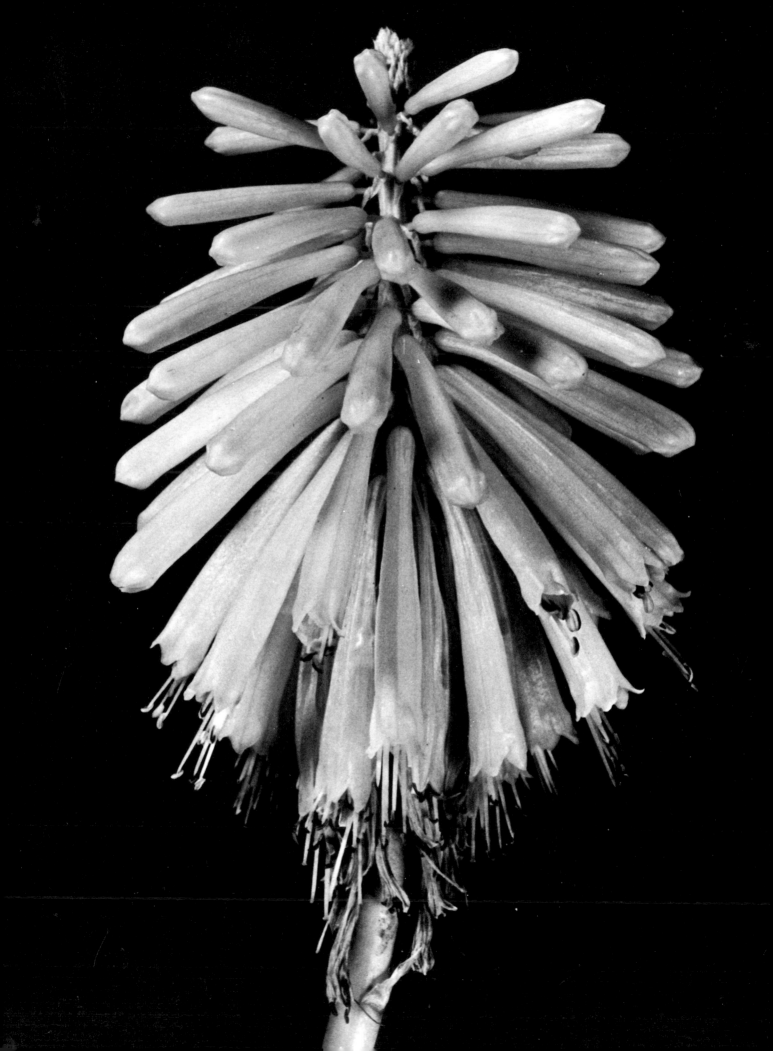

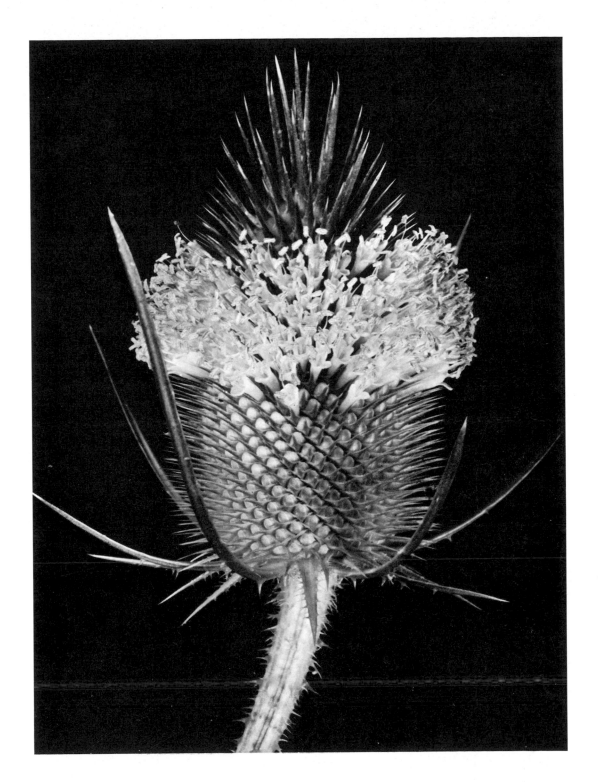

TEASEL, X 3
Dipsacus sylvestris Huds.

The teasels, introduced from Europe, have an interesting history. For centuries the bristly fruiting heads of a species closely related to the one illustrated here have been used to comb up or tease a hairy layer or nap on wool cloth. Originally brought to America for this purpose, these plants now are usually considered weeds.

Opposite: TORCH LILY, X 3
Kniphofia sp. or *Tritoma* sp.

Borne on a tall stem, this cluster of orange or yellow flowers is a common feature of many gardens.

BULL THISTLE, X 4
Cirsium pumilum (Nutt.) Spreng.
The flowering head consists of one hundred or more little flowers packed tightly together. Were it not for this weed's formidable spines and territorial ambitions, it might be cultivated in many gardens.

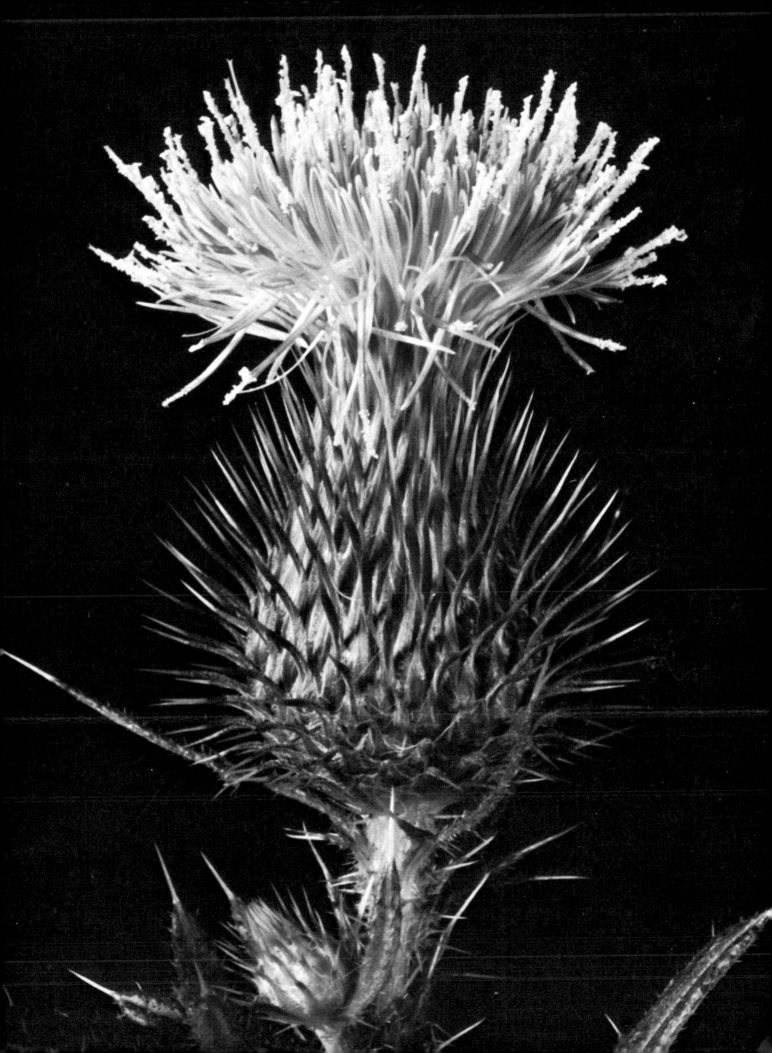

PASSION-FLOWER, X 3
Passiflora sp.
The first Spaniards in South America connected the flower's structure with the signs of the Crucifixion: The three upper parts of the pistil became the three nails, the five stamens were the five wounds, surrounded by a crown of thorns. The ten "petals" represented the ten apostles at the Crucifixion.

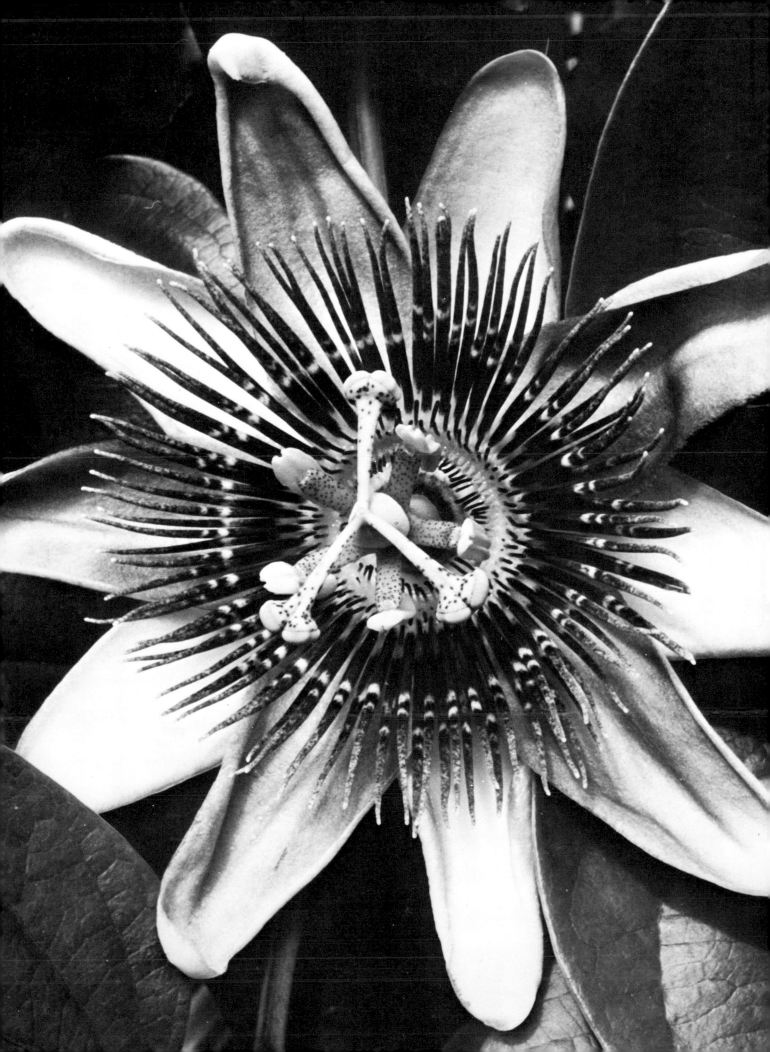

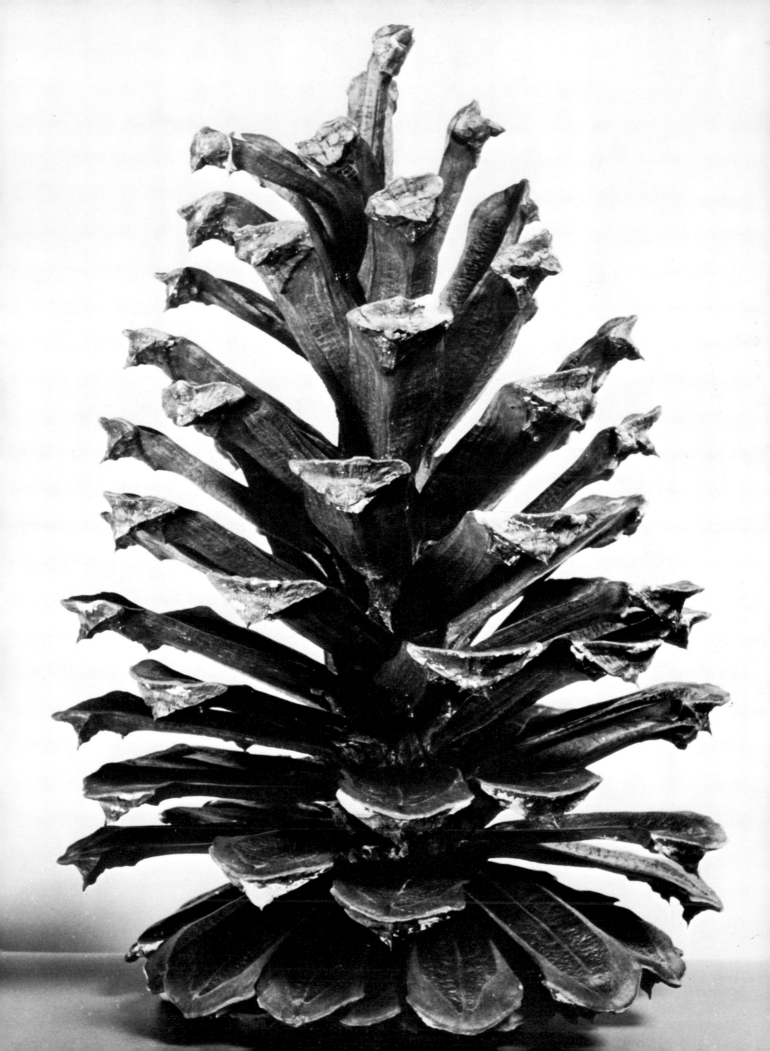

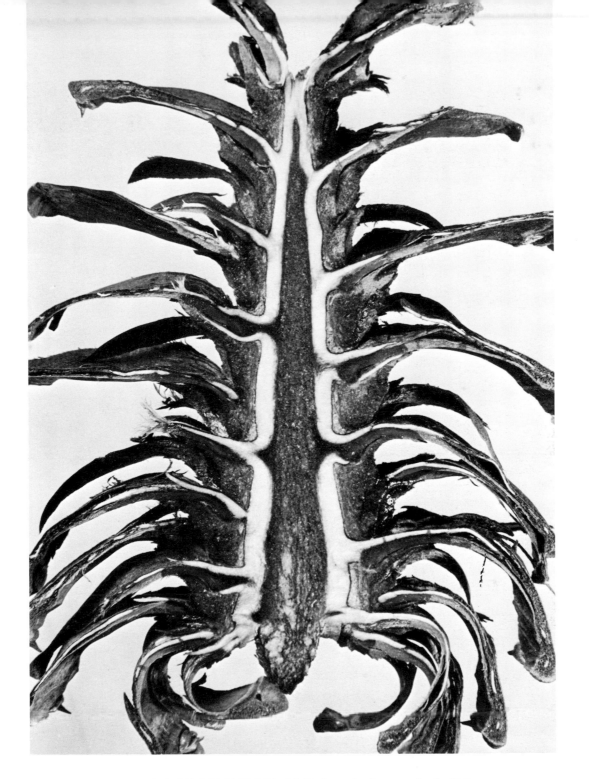

CONE OF PONDEROSA PINE (lengthwise section), X 2
Pinus ponderosa Laws.
The opening and closing mechanism of the scales of a pine cone is remark-
able. Each scale in section shows a white upper band of tissue and a brownish
lower band. The white band shrinks very little when the cone dries out; the
lower band may shrink lengthwise from 20 to 30 percent or more. This
shrinkage causes the scale to curve away from the cone axis and exposes the
seeds. The wood in a tree usually shrinks less than .1 to .3 percent when dried.

Opposite: CONE OF PONDEROSA PINE, X 3
Pinus ponderosa Laws.
Cones used for decoration have usually already opened. To observe an open
cone closing, simply place it in water; within an hour or two the scales close.
On dry sunny days after a cone reaches maturity the scales open releasing
winged seeds; in rainy weather, poor for "flying," the scales remain closed.

63

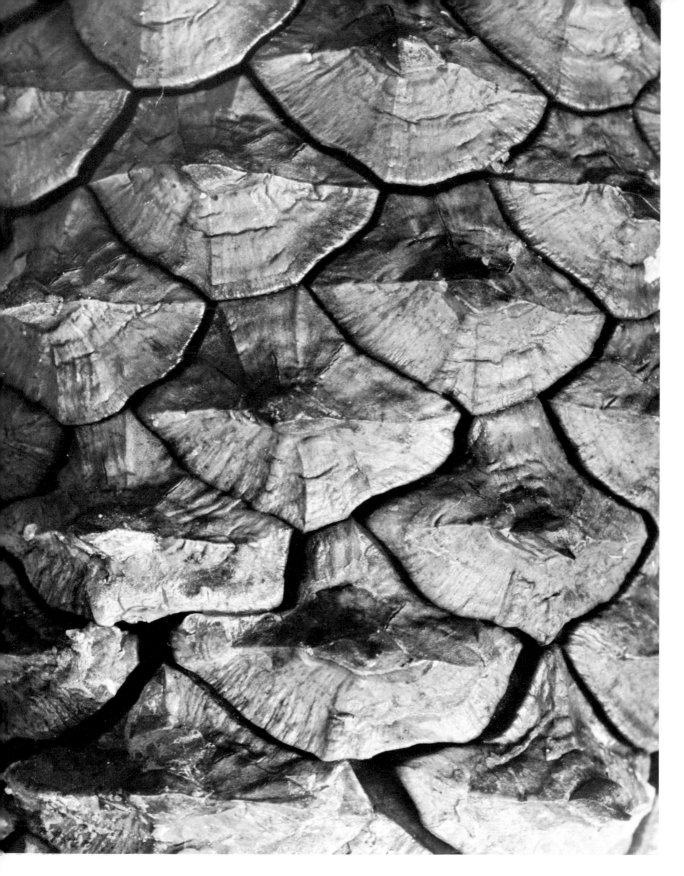

RED PINE CONE SCALES, X 4
Pinus resinosa Ait.
The overlapping scales of pine cones look something like shingles on a roof. Unlike shingles, they are arranged in beautifully complex mathematical spirals.

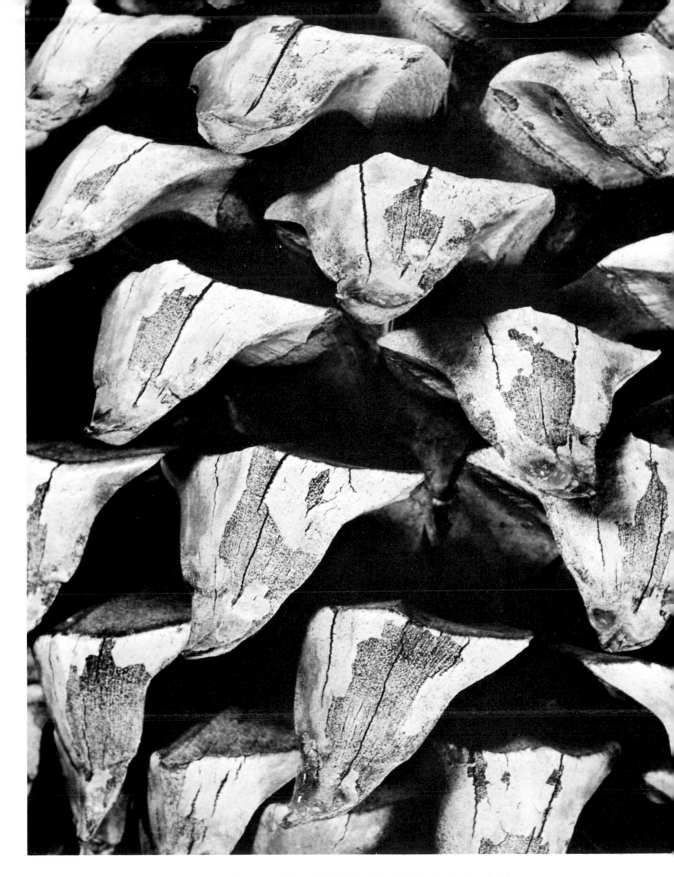

WEATHERED CONE SCALES OF COULTER PINE, X 2
Pinus coulteri D. Don
These cones are truly massive. Nearly a foot long, when green they may weigh
between four and six pounds. The netlike texture of most of the scales was
produced over several years by weathering as the cones lay on the ground.

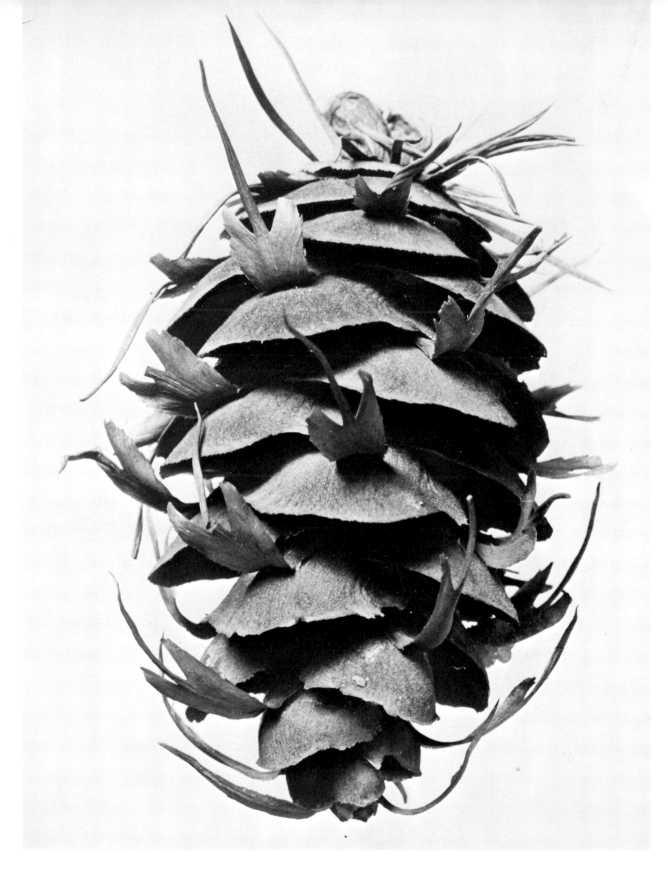

CONE OF DOUGLAS-FIR, X 2½
Pseudotsuga menziesii (Mirb.) Franco
This species is the most important single timber producer in the United States and is also widely planted as an ornamental. The two-lobed bracts, each with a central spine or tail, make its cone easy to recognize. Mr. R. E. Horsey, a former curator of the Highland Park Arboretum at Rochester, New York, called this "the tree with mousetrap cones."

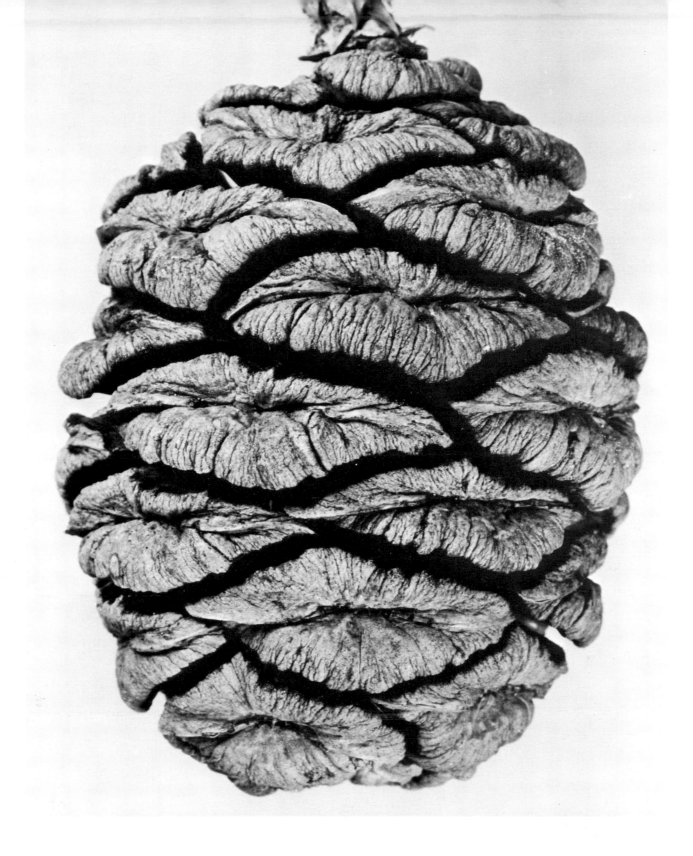

CONE OF GIANT SEQUOIA, X 3
Sequoiadendron giganteum (Lindl.) Buchholz
The giant sequoia or big-tree of the Sierra Nevada Mountains in California is one of the world's most famous and awe-inspiring trees. Even medium-sized trees are 75 feet around at the base. With the light from a whitely overcast sky, the great trunks glow a rosy red. The tree, which is known to attain an age of about 3,000 years, was once thought to be the world's oldest. That distinction now belongs to the bristlecone pine, the oldest known example having attained an age of about 4,900 years.

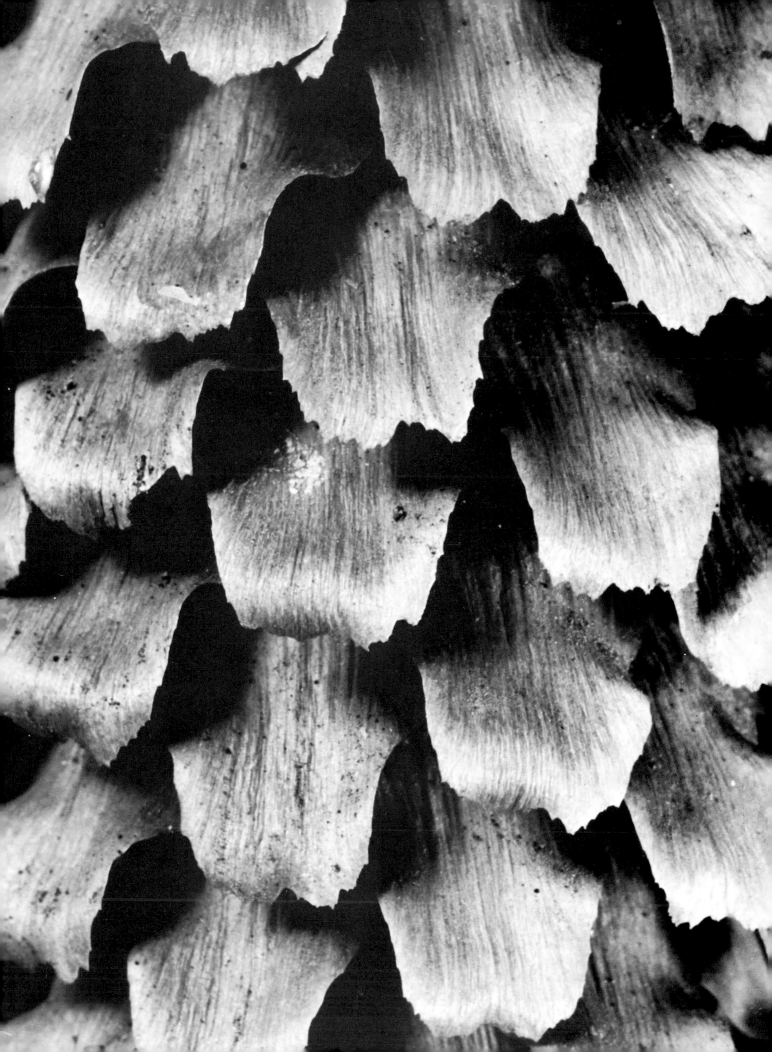

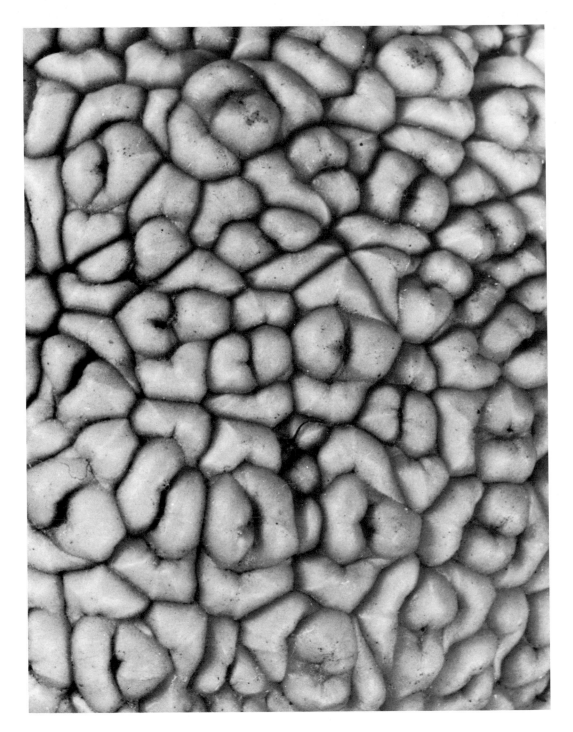

FRUIT SURFACE OF OSAGE-ORANGE, X 6
Maclura pomifera (Raf.) Schneid.
The green, ball-shaped fruit with its bitter milky sap is about 4 inches in diameter and has a strangely sculptured surface unlike that of any other native species.

Opposite: CONE SCALES OF BLUE SPRUCE, X 7
Picea pungens Engelm.
Blue spruce, native to the Rocky Mountains, has now become one of the commonest and most widely planted ornamentals of North America. The cones are about 3½ inches long; the spiral arrangement of the scales is typical of many conifers.

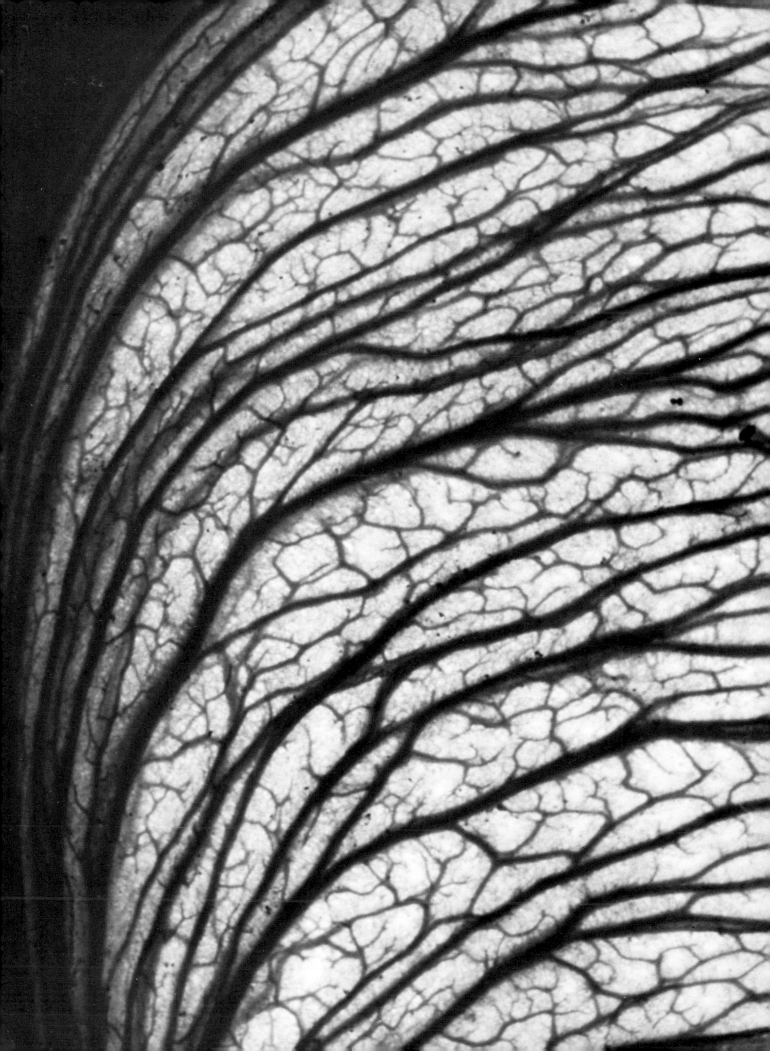

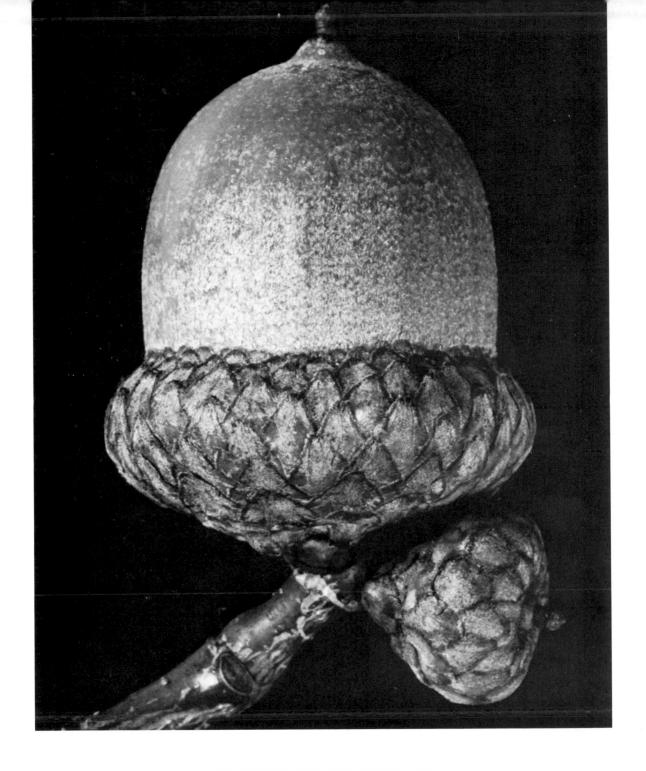

NORTHERN RED OAK ACORN, X 8
Quercus rubra L.

This oak is one of our important forest trees. Even at natural size the acorn is the largest of those in northeastern red oaks. To one viewer, the photograph looked like "a throng of hooded worshippers under the dome of a great oriental mosque."

Opposite: WING VEINS IN SILVER MAPLE, X 12
Acer saccharinum L.

The winged fruits of the maples are well adapted for traveling by air. Maple "keys" have been seen lofted by 60-mile-per-hour winds, spinning along 150 feet above the ground. The vein framework of the wing suggests an effective aeronautical design.

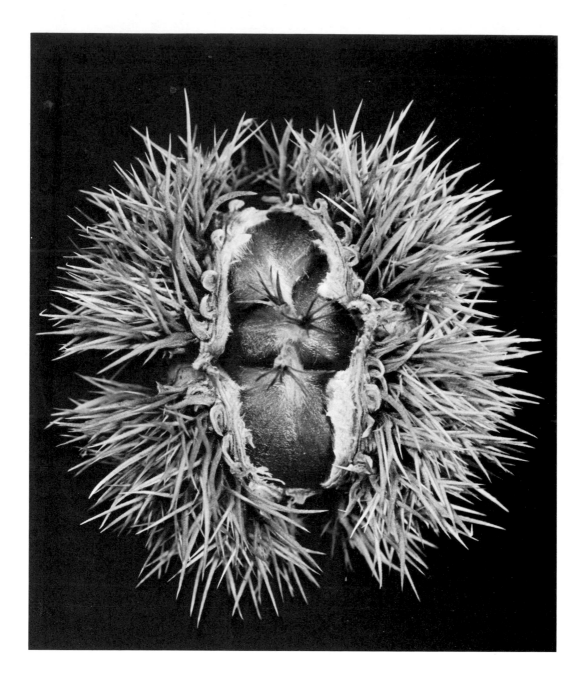

CHESTNUTS IN BUR, X 3
Castanea dentata (Marsh.) Borkh.
The valuable American chestnut tree has been all but wiped out by the chestnut blight, caused by a fungus brought from Asia at the turn of the century. Asiatic chestnut trees are somewhat resistant to the fungus, and it is hoped that hybrids between our native tree and the Chinese chestnut may be disease-resistant and also possess the desirable qualities of the American chestnut.

Opposite: CHESTNUT BUR SPINES, X 8
Castanea dentata (Marsh.) Borkh.
No mammal can get at a chestnut until the frost opens its spiny husk. Beneath the spines is a hard horny layer, and inside of that a thick blanket of velvet. The seed itself is enclosed in a leathery case.

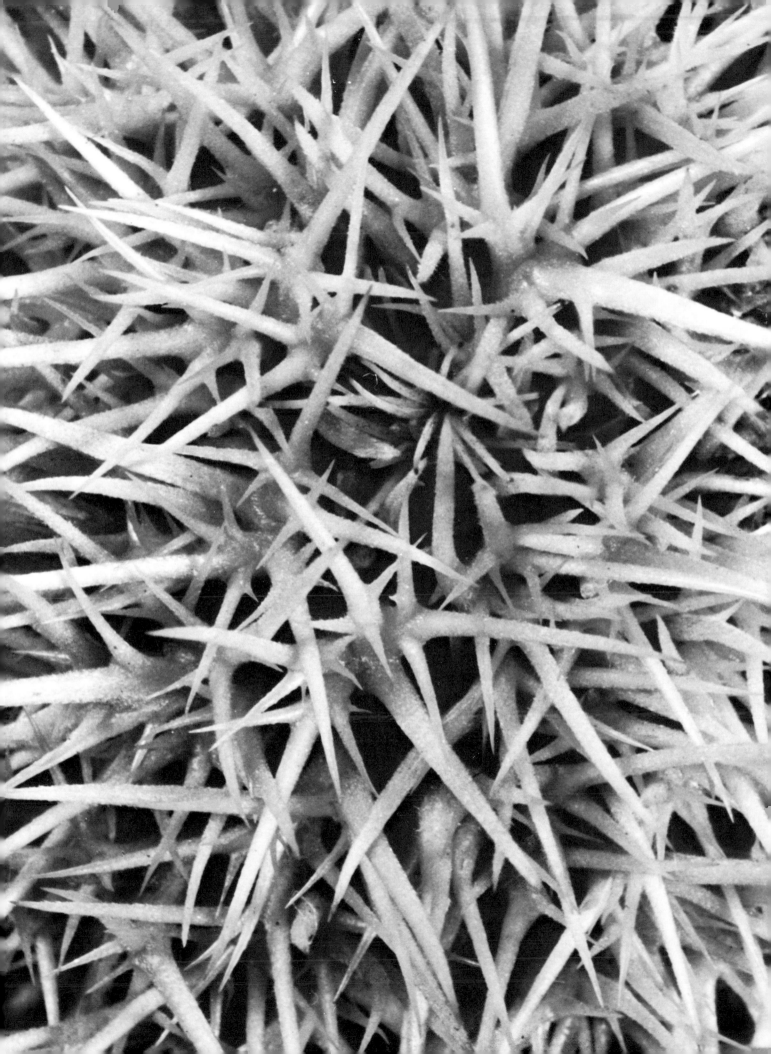

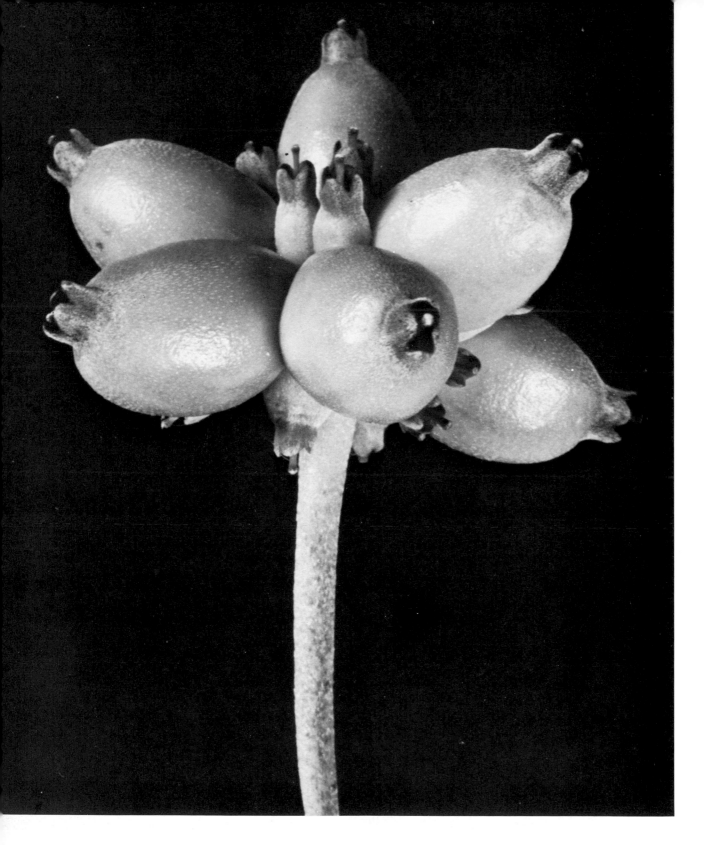

FLOWERING DOGWOOD FRUIT CLUSTER, X 6
Cornus florida L.
Six of the flowers have developed into bright red fruits. Those that aborted may still be seen attached to the floral disk.

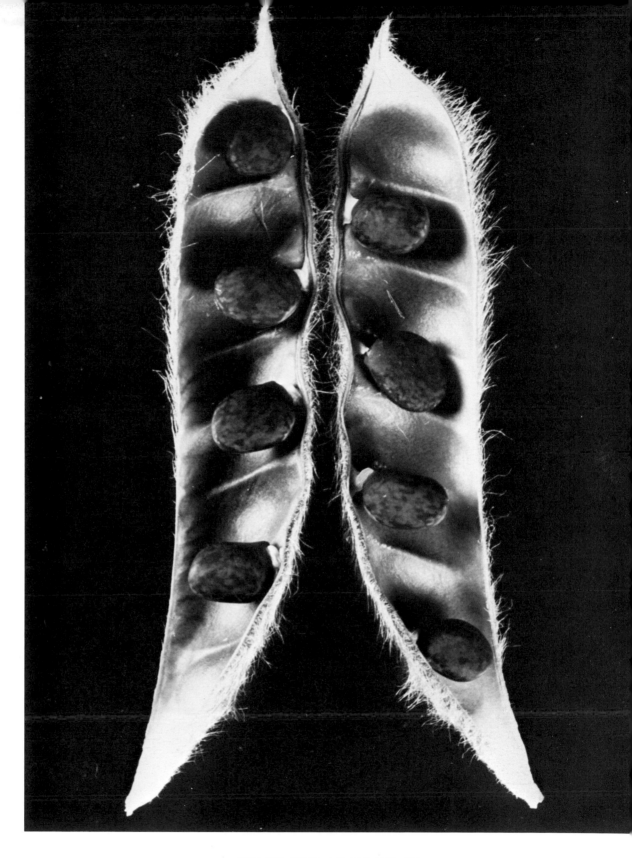

OPENED POD OF LUPINE, X 5
Lupinus sp.

As lupine pods dry, they twist; this may cause the seeds to spring away from the parent plant. Blue lupines by the thousands mark high mountain slopes of the West. Annual and perennial species in several colors are garden favorites as well.

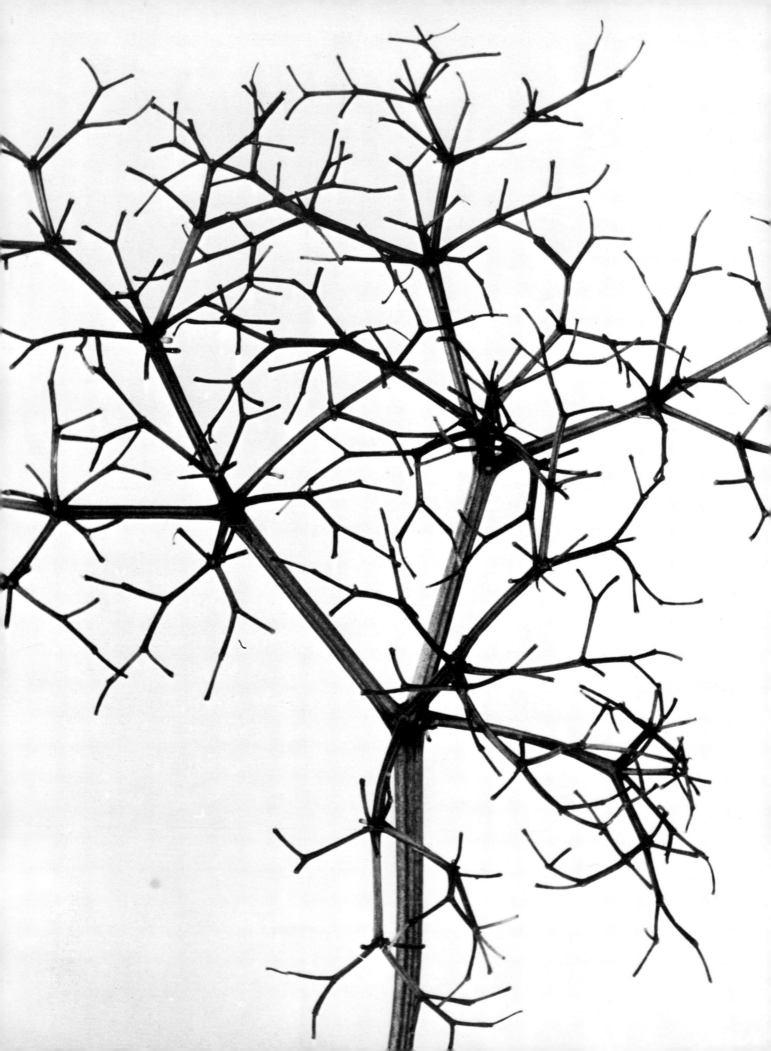

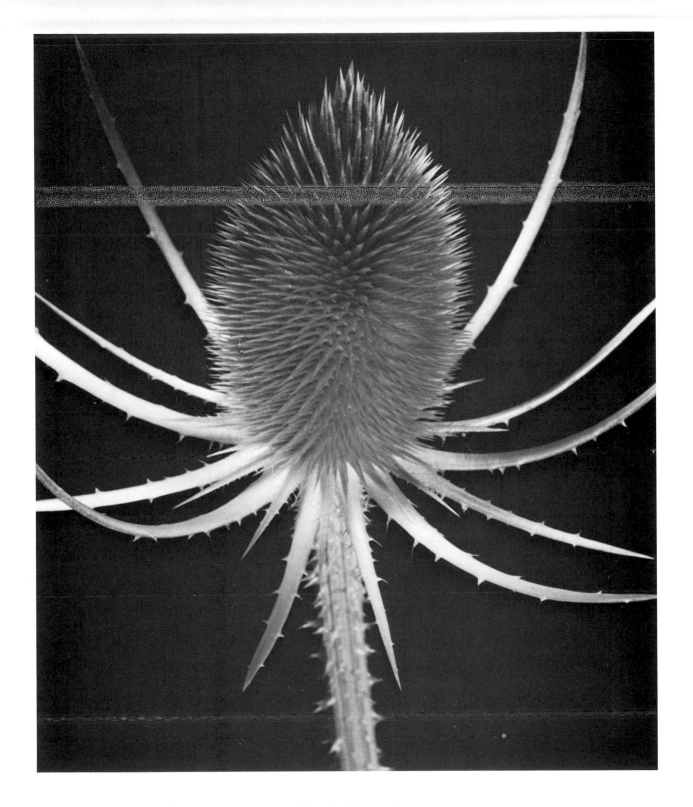

WILD TEASEL, X 1½
Dipsacus sylvestris Huds.
This is the mature fruiting head shown in flower on page 57. A tall, biennial spiky weed that says "do not touch," it has nevertheless a beautifully artistic seed-bearing structure. They are often gathered in autumn and used in various arrangements or displays.

Opposite: ELDERBERRY STEMS, X 4
Sambucus canadensis L.
This pattern remains after birds have picked off the last elderberries from a cluster of two hundred or more.

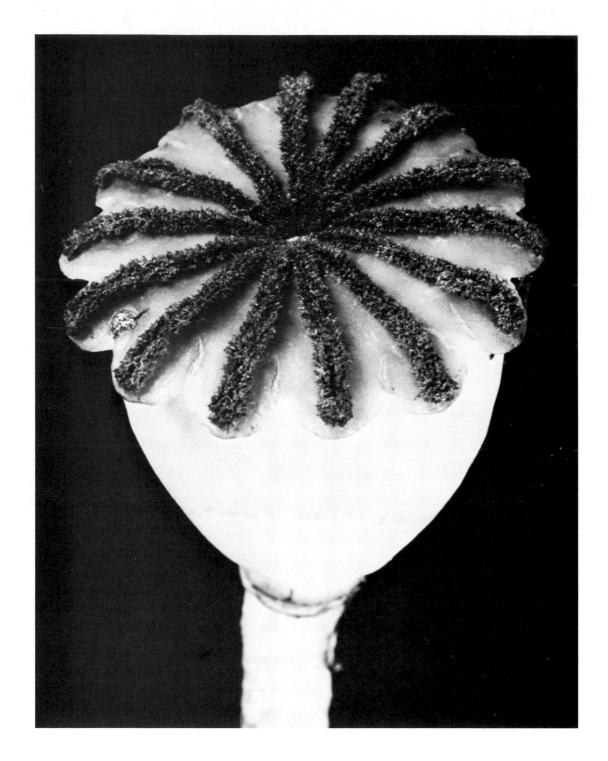

FRUIT CAPSULE OF ORIENTAL POPPY, X 6
Papaver orientale L.
The radial pattern of the stigma on the top of the fruit capsule provides an unusual design.

Opposite: FRUIT CAPSULE OF ICELAND POPPY, X 12
Papaver nudicaule L.
When the wind blows hard or an animal brushes against the long stiff stem, some of the minute seeds are thrown out of the pores or openings on the top of the capsule.

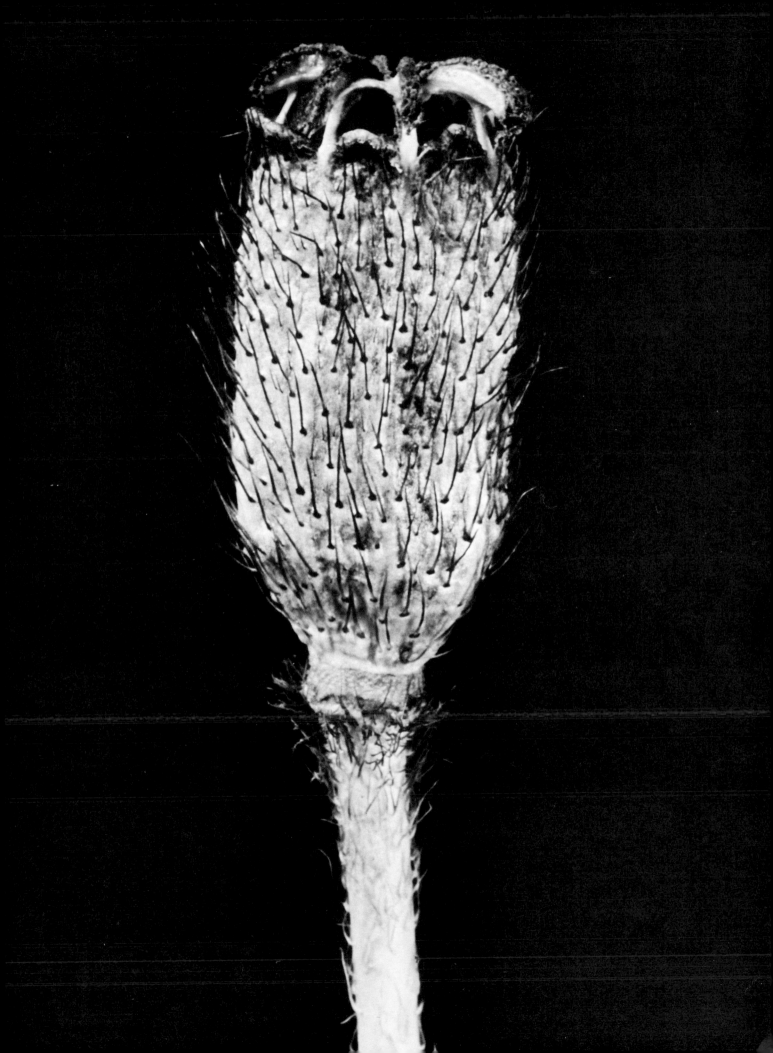

STORKSBILL FRUIT, X 7 AND X 12
Erodium sp.
This is one of the most remarkable structures in nature. The seed is contained in a "gimlet" that burrows into the ground. When wet, the stalk is straight; as it dries, it begins to twist, raising the boring end at an angle. Every change of moisture results in motion. The bristles help to anchor the drill tip.

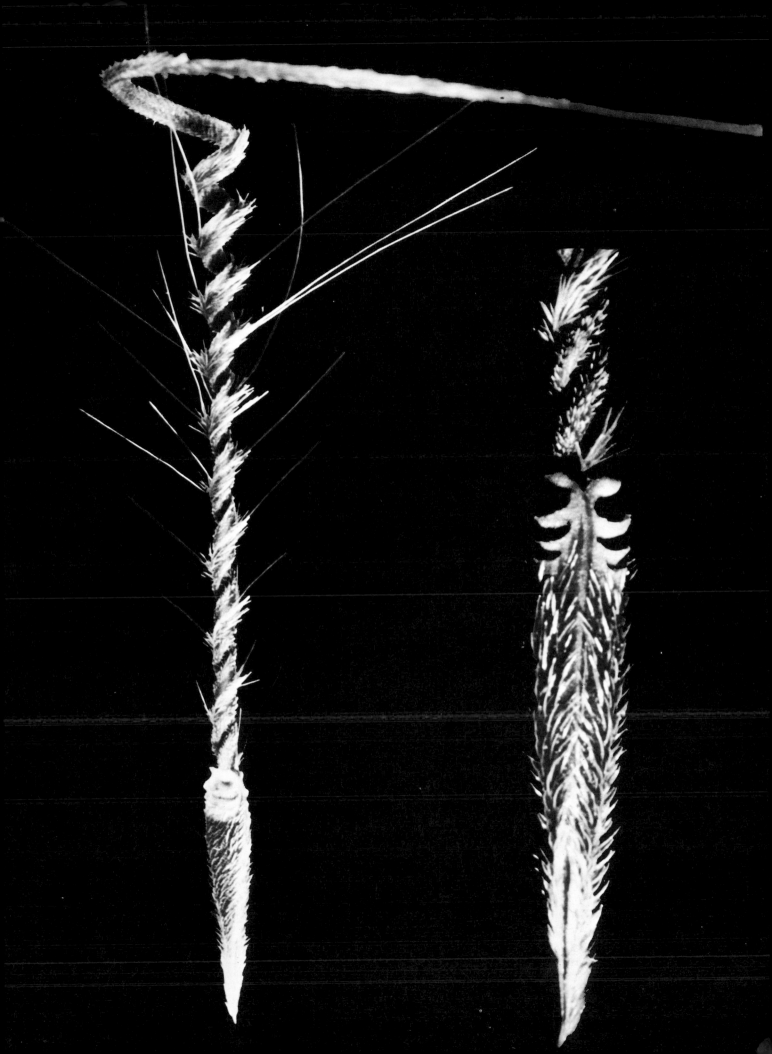

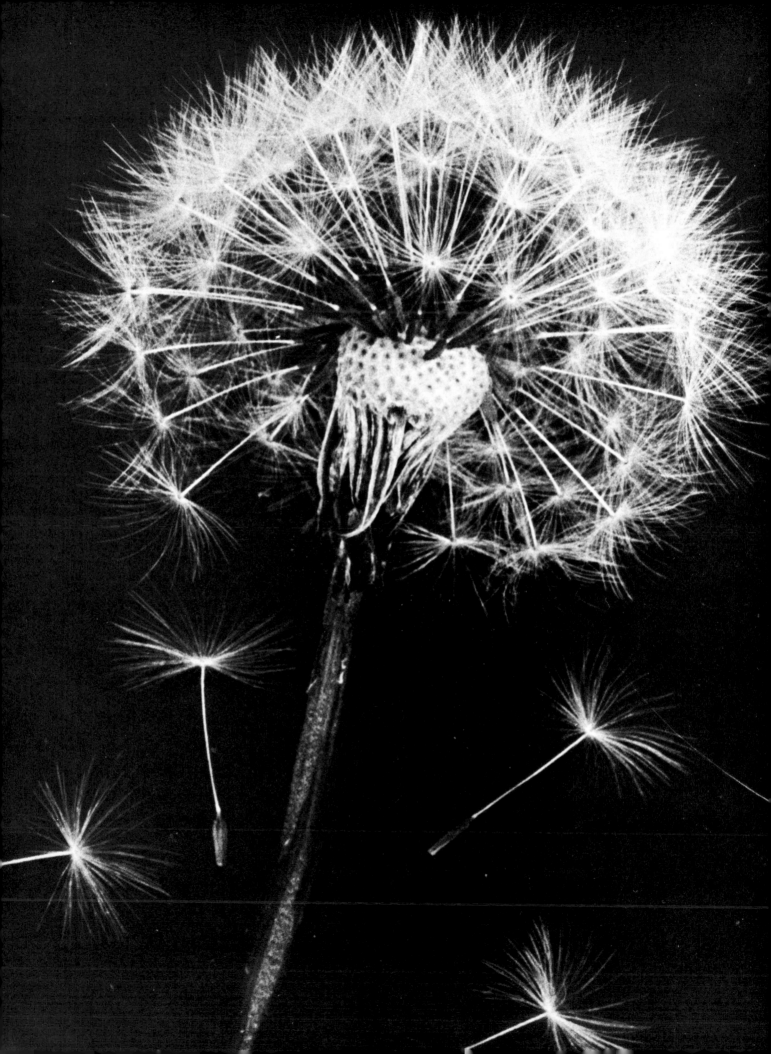

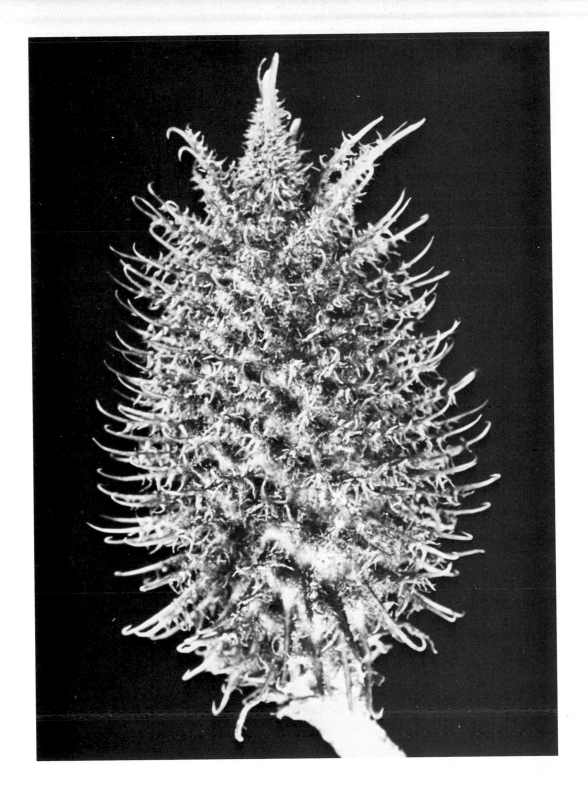

COCKLEBUR, X 5
Xanthium sp.
The hard, stiff, hooked spines of the cocklebur make it efficient in "hitching"
rides on passing animals, including man.

Opposite: DANDELION GONE TO SEED, X 4
Taraxacum sp.
Each fruit, or "seed," has a parachute capable of carrying it for long distances.

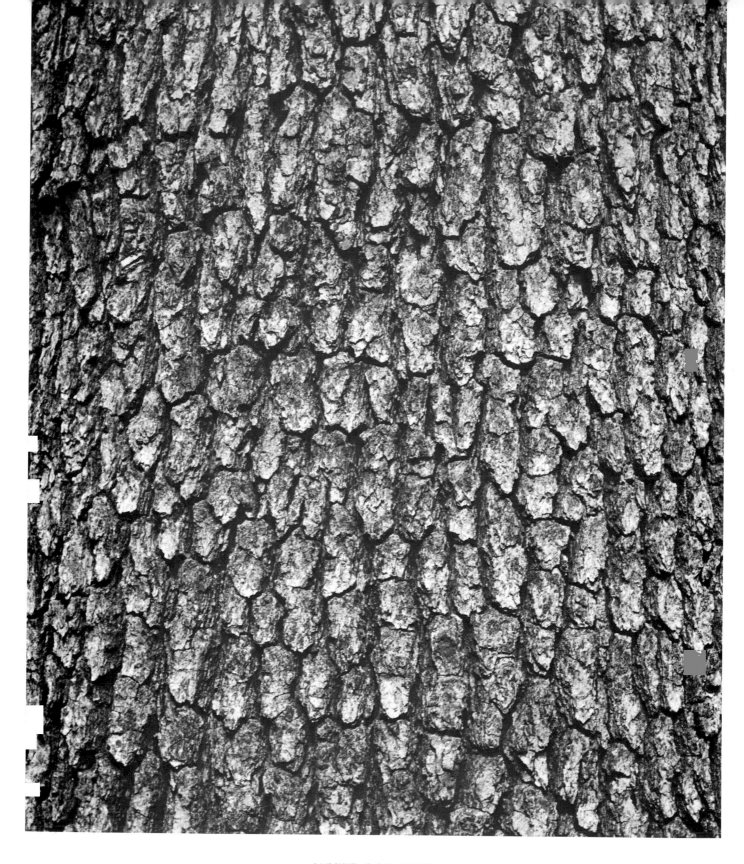

WHITE OAK BARK
Quercus alba L.
The bark patterns of most trees change greatly from youth to old age, yet each design is intriguing. This is an old tree.

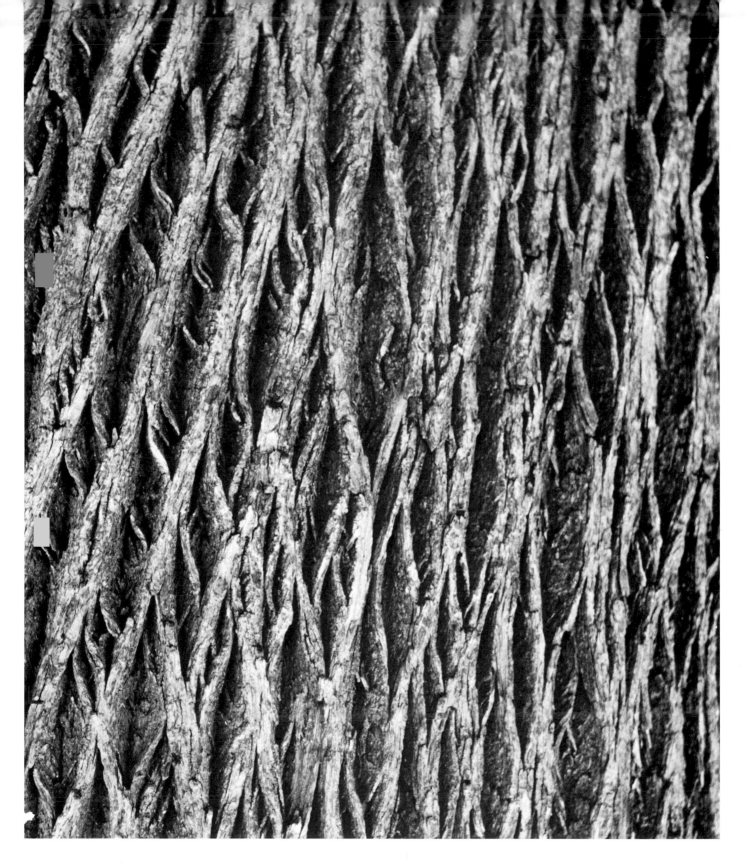

WHITE ASH BARK
Fraxinus americana L.
One sees in bark patterns a similarity to the landscape with its hills and valleys.
Here the pattern is of diamond-shaped valleys bounded by a network of
flat ridges.

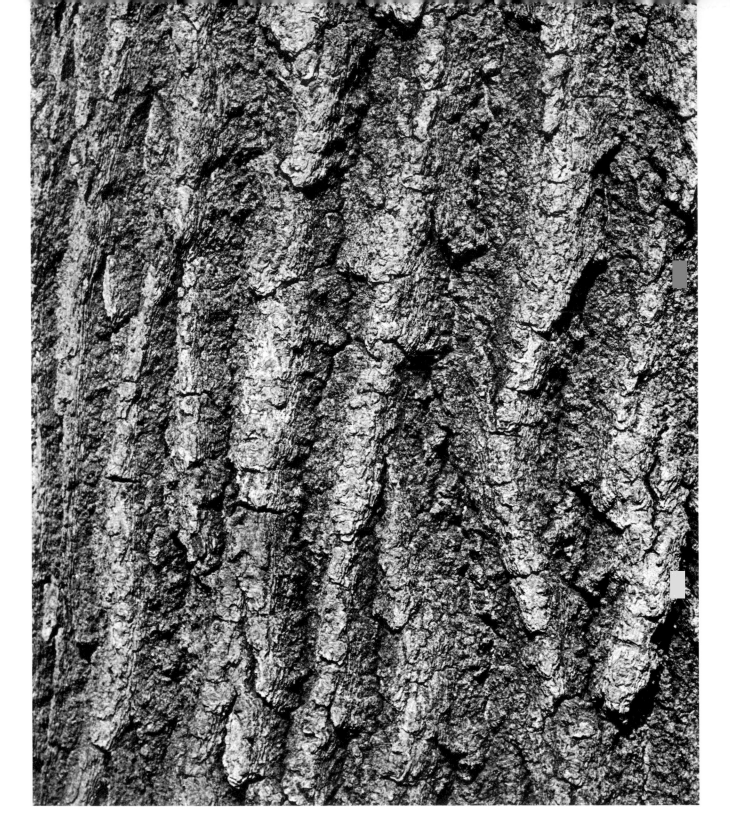

RED OAK BARK
Quercus rubra L.
In colonial days, tannin was a valuable product extracted from oak bark and used in producing leather from raw skins. Today quebracho wood from South America provides much of the commercial tannin used in the United States.

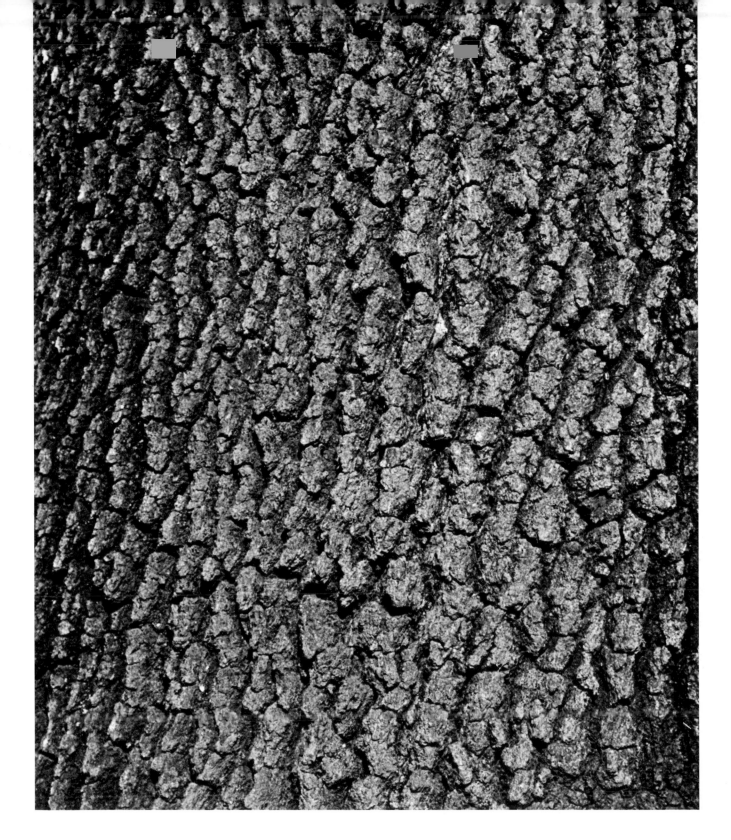

LIVE OAK BARK
Quercus virginiana Mill.
This enormous Southern tree (max. diameter some ten feet) shows again how bark patterns vary from one species to another. When grown in the open, huge spreading branches divide near the ground to form a crown of evergreen leaves, one hundred feet or more across.

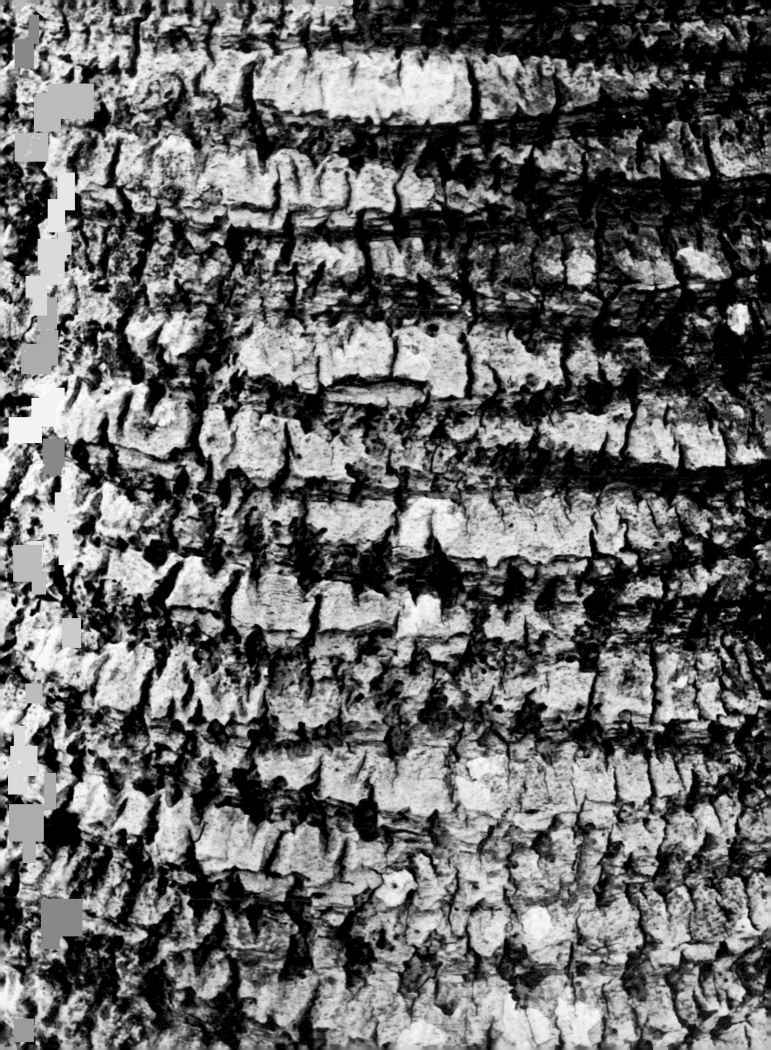

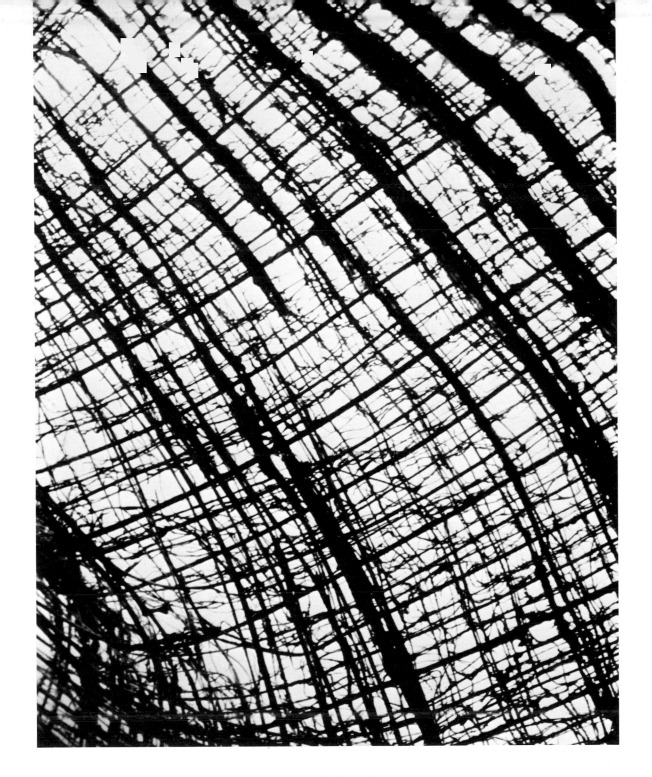

PALM TREE FIBER
Livistona chinensis R. Br.
As the leaf bases weather, layers of interlacing fibers separate and fall off.
Photographed against the sun, varied patterns appear in silhouette.

Opposite: DATE PALM TREE
Phoenix canariensis Hort.
As with other palms, the outer surface of the stem is roughened where the
leaves once grew.

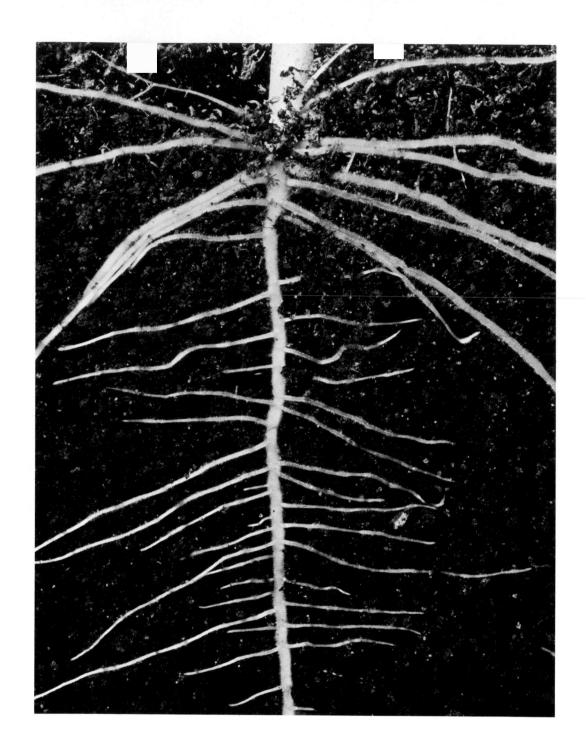

ROOT SYSTEM OF BEAN, X 2
Phaseolus vulgaris L.
From a long, fast-growing taproot, lateral roots emerge. Behind each root tip is a zone of numerous root hairs which absorb water and minerals from the soil. See fuzzy appearance along roots at top of page.

Opposite: FIG TREE ROOTS
Ficus elastica Nois
Trees have extensive root systems extending down and outward to about the same distance from the trunk as the branch tips overhead. Here, however, the roots lie on the surface and look much like a river system or a collection of bones.

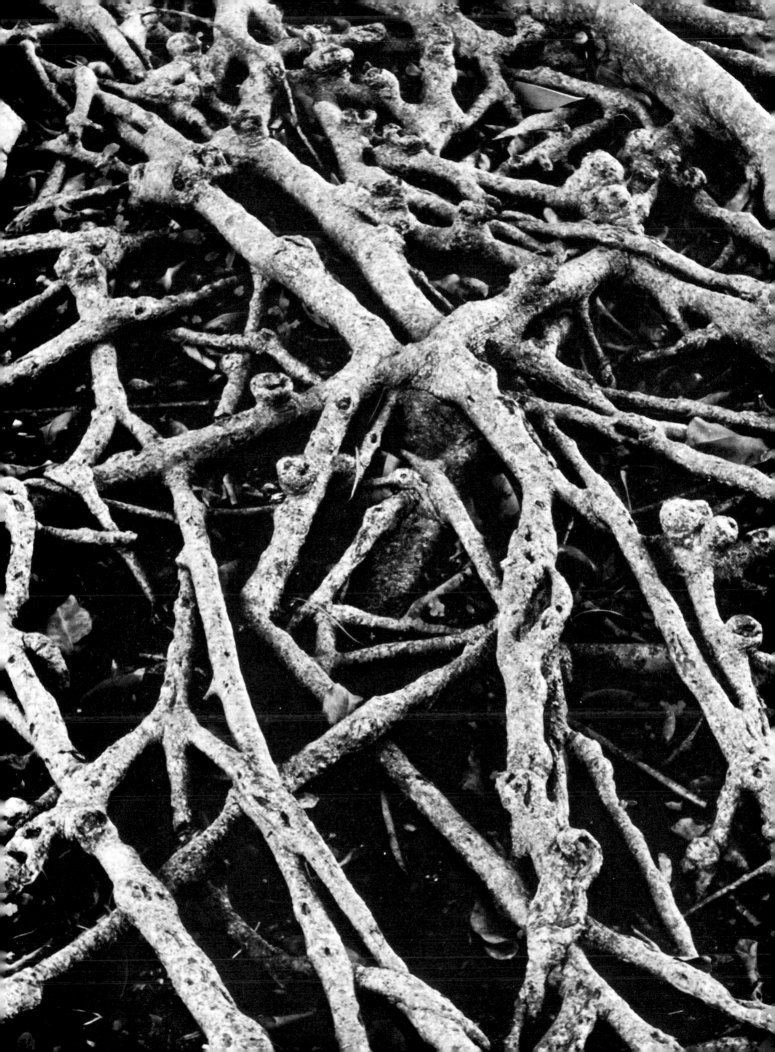

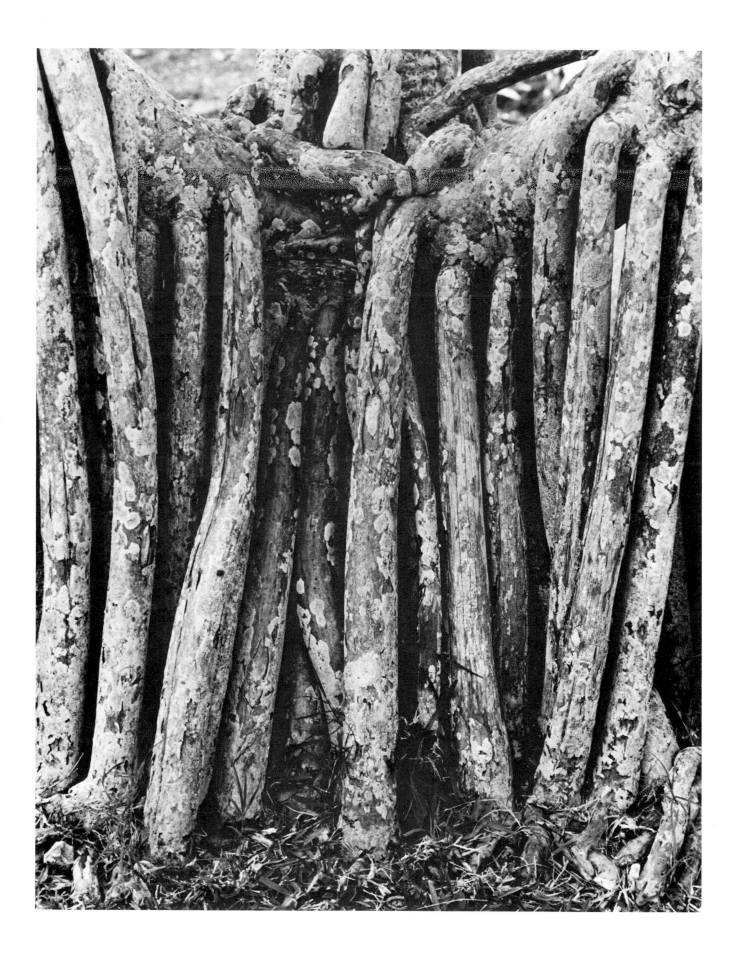

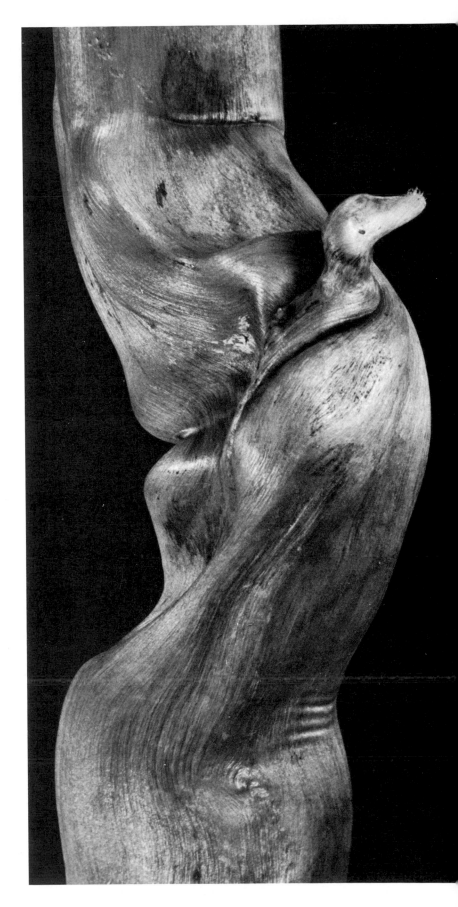

Opposite: SCREW-PINE AIR ROOTS
Pandanus utilis Bory
There is nothing pinelike about this tropi-
cal tree with aerial roots that grow down
from the lower trunk to the ground. Its
name may have derived from its cone-
shaped fruit.

ROOT OF COTTONWOOD TREE
Populus deltoides Bartr.
This horizontal root grew among smooth,
water-washed pebbles and larger stones
on the shore of Lake Ontario. Perhaps
the tree was washed out during a storm,
and the broken root was tumbled in the
surf until the bark was scoured away and
the surface of the wood achieved its silky
texture. Some have titled this "Woman
with Duck."

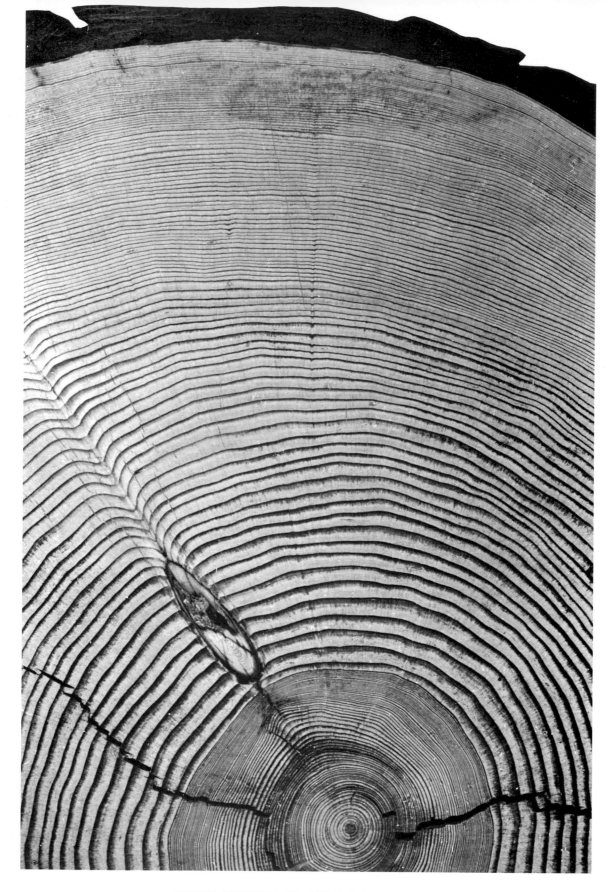

CROSS SECTION OF HEMLOCK TREE, X 1
Tsuga canadensis (L.) Carr.
For 75 years this tree grew very slowly under heavy shade. Then the surrounding trees were cut, and suddenly the tree had more than adequate light and soil moisture. The tree's response was remarkable; the rings are ten times the width of those formed before the tree was liberated.

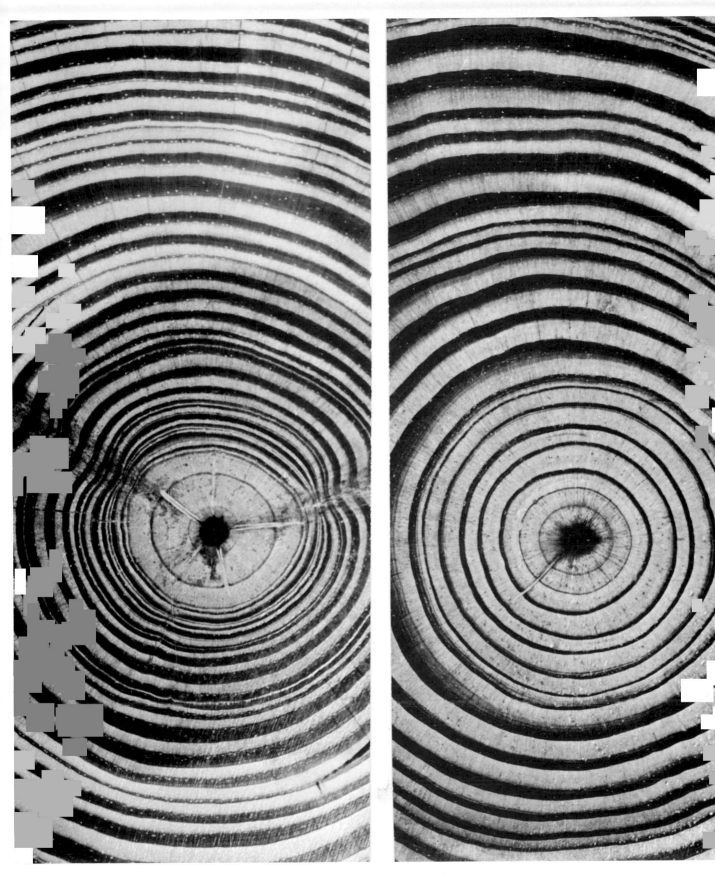

TREE RINGS OF SOUTHERN PINE
Pinus sp.
The history of a tree is recorded in its growth rings. The young tree on the left was probably enveloped by a fire which burned its needles. Plant food (principally sugars) is made only in green leaves, so growth faltered and then recovered, as indicated by the rings of normal width toward the top of the picture. The tree on the right grew normally from the beginning.

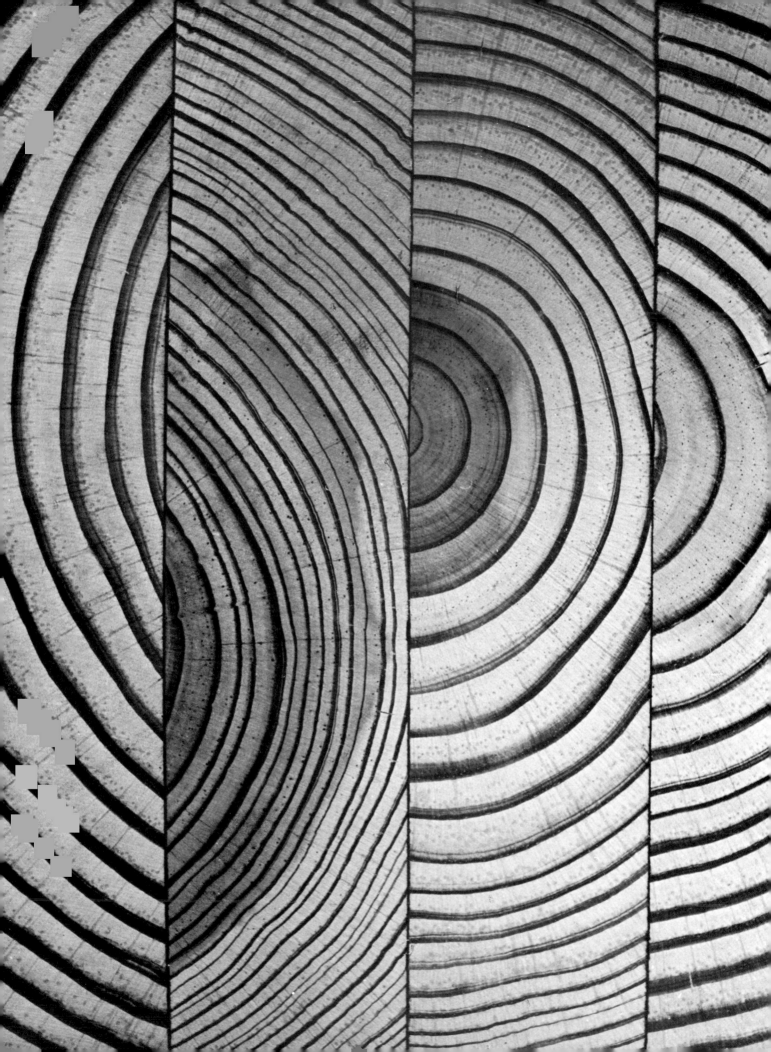

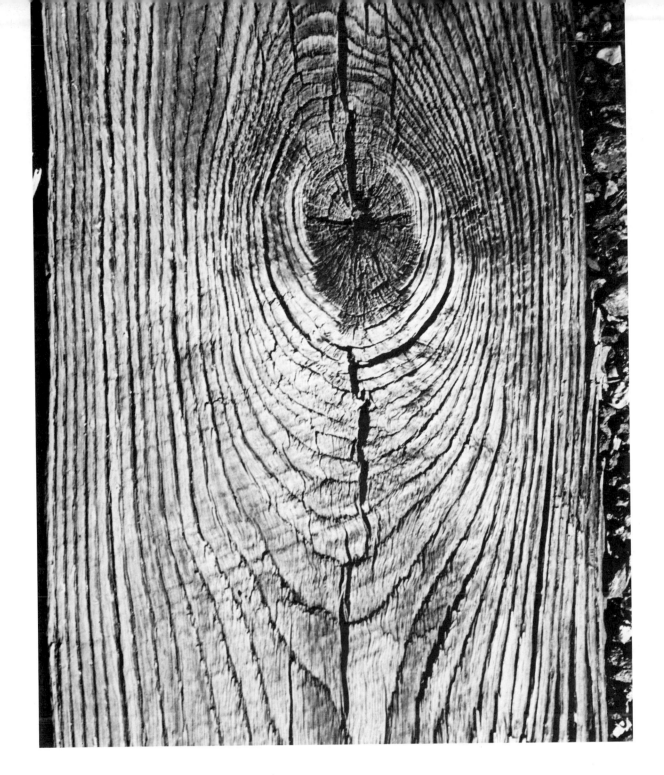

WOOD GRAIN PATTERN IN OAK
Quercus sp.
From this weathered oak railroad tie, we can see how the growth layers of a branch merged with those of the main trunk. A knot is simply an embedded branch, seen here in cross section.

Opposite· CROSS SECTION OF LAMINATED BEAM
A modern architectural use of wood is the laminated beam. Each piece or laminate has its own distinctive ring pattern.

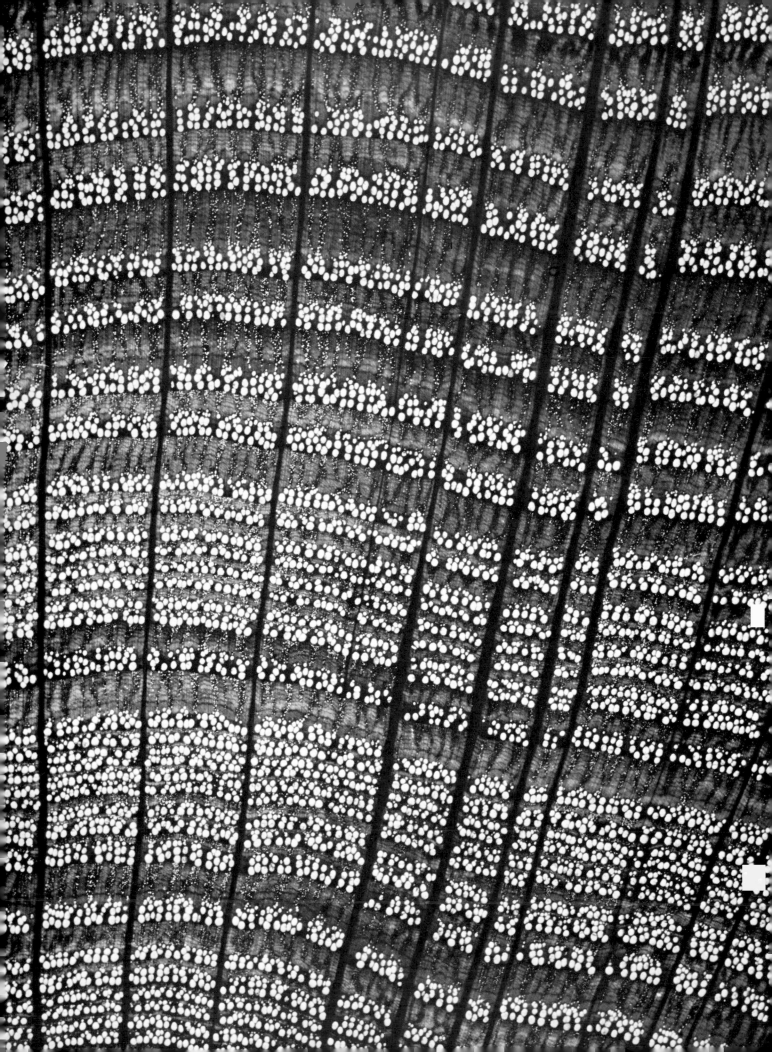

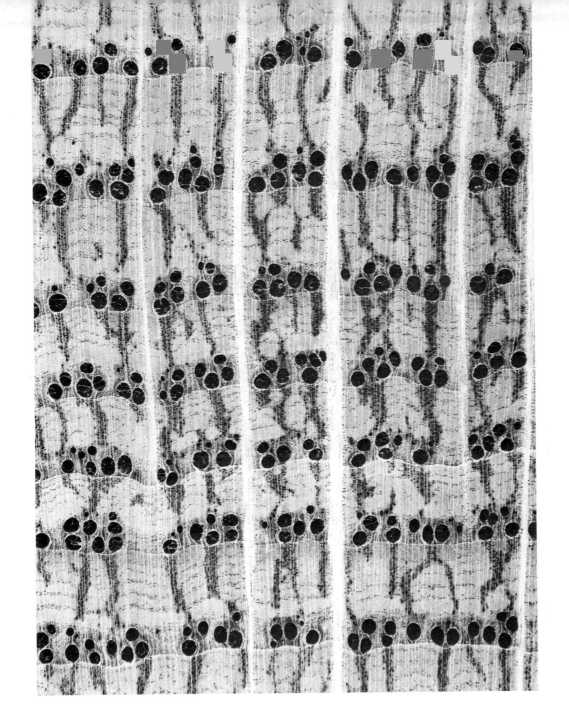

CROSS SECTION OF WHITE OAK WOOD, X 10
Quercus alba L.
In this negative image, it appears that you are looking down into the wood structure instead of through a thin section lighted from behind.

Opposite: CROSS SECTION OF BUR OAK WOOD, X 6
Quercus macrocarpa Michx.
The width of the porous earlywood in each ring of this white oak varies little from one ring to the next. The latewood varies markedly; the wider the rings, the more there is of the heavy, strong, latewood.

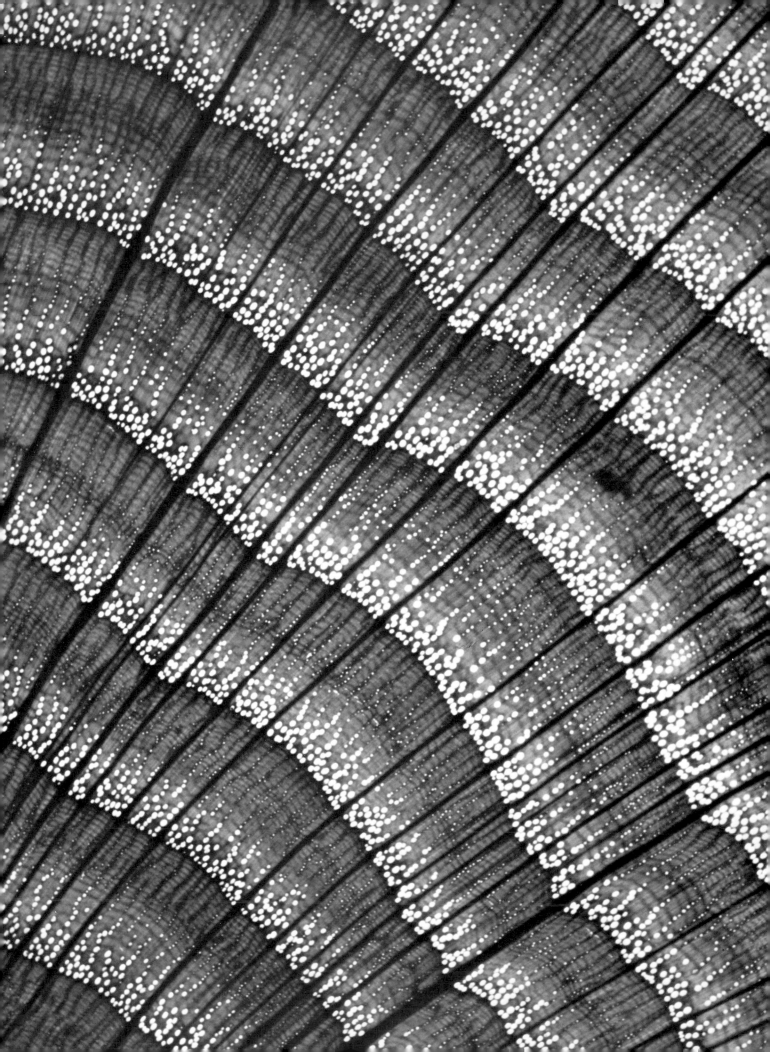

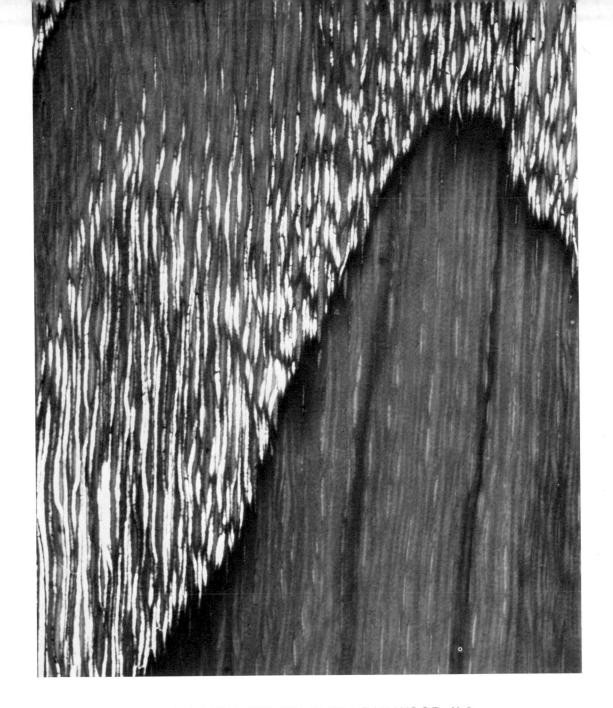

TANGENTIAL SECTION OF PIN OAK WOOD, X 8
Quercus palustris Muenchh.

A lengthwise section of a piece of wood shows a completely different pattern from that of its cross section. The large earlywood pores are seen as long sap-conducting tubes that look like little flames. The dark "mountain" is the dense latewood along the outer edge of the growth ring.

Opposite: CROSS SECTION OF PIN OAK WOOD, X 8
Quercus palustris Muenchh.

This pin oak tree grew much faster than the bur oak. The latewood pores, though small and few in number, are readily visible. This is a feature of wood in the red oak group.

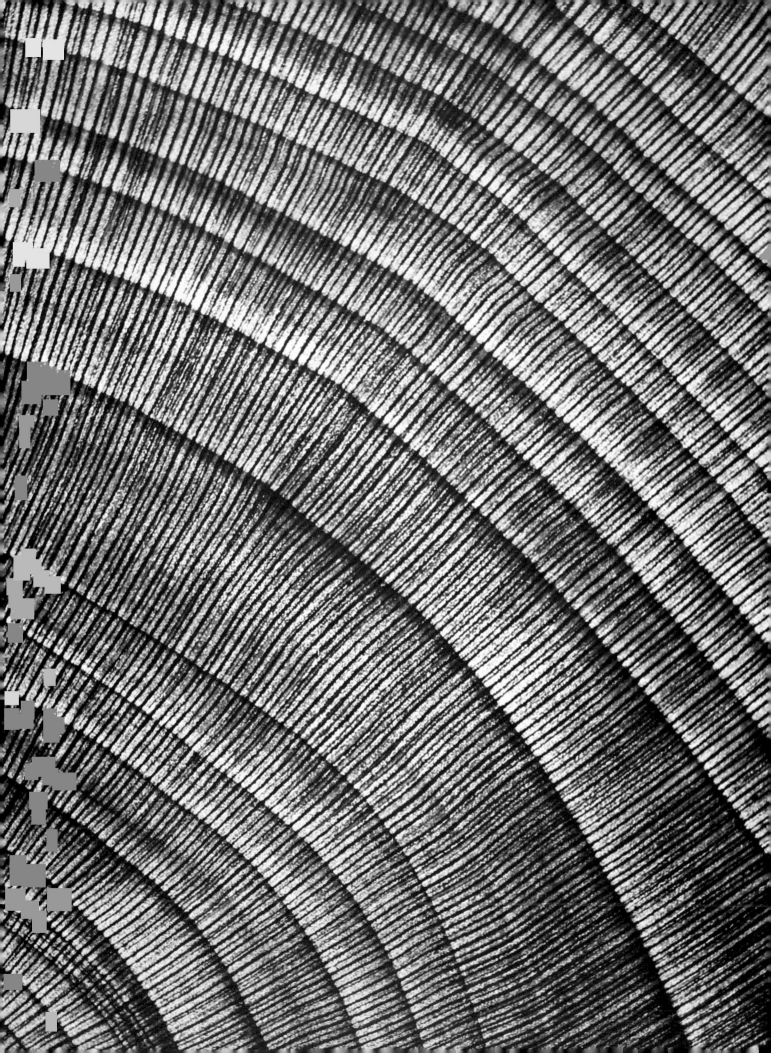

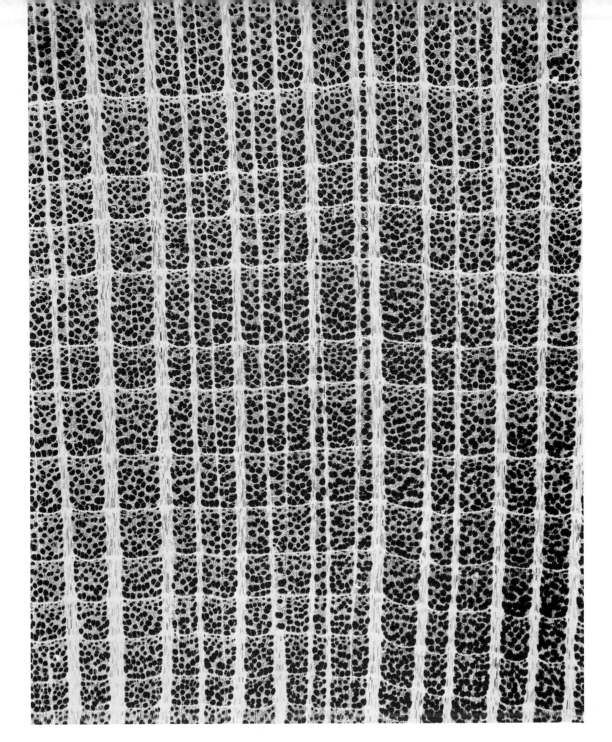

CROSS SECTION OF AMERICAN SYCAMORE WOOD, X 25
Platanus occidentalis L.
At this magnification, the thousands of pores are easily seen—in fact, the structure is so porous that the volume of air space may equal that of the solid wood substance. The broad wood rays running from top to bottom are one of the features of sycamore wood.

Opposite: CROSS SECTION OF AMERICAN SYCAMORE WOOD, X 6
Platanus occidentalis L.
Unlike the oak, the sap-conducting tubes of sycamore are about the same size throughout the ring; they are small compared to those in the earlywood of the oaks.

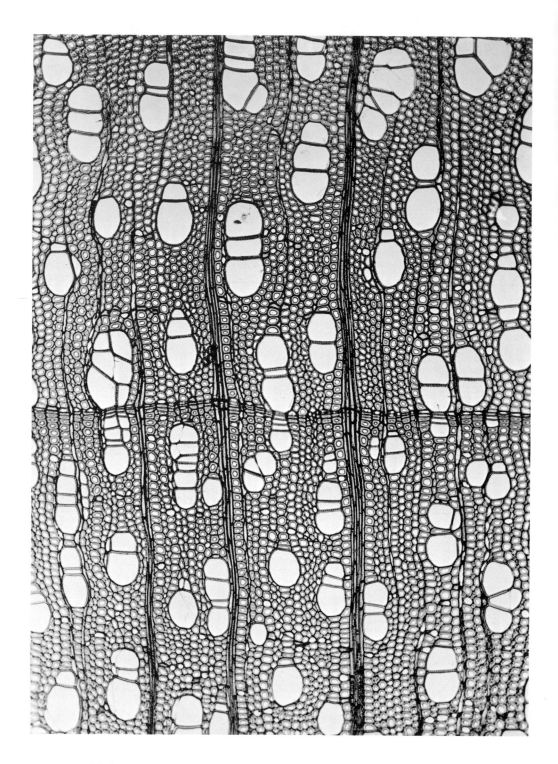

CROSS SECTION OF SWEET (BLACK) BIRCH WOOD, X 80
Betula lenta L.
At this magnification, only parts of two growth rings are seen. The pores are prominent, and the thick-walled strengthening cells are now visible. Remember that the pores are openings to long sap-conducting tubes. The strengthening cells are long wood fibers.

Opposite: CROSS SECTION OF SWEET (BLACK) BIRCH WOOD, X 220
Betula lenta L.
By nearly tripling the magnification, even greater detail is seen.

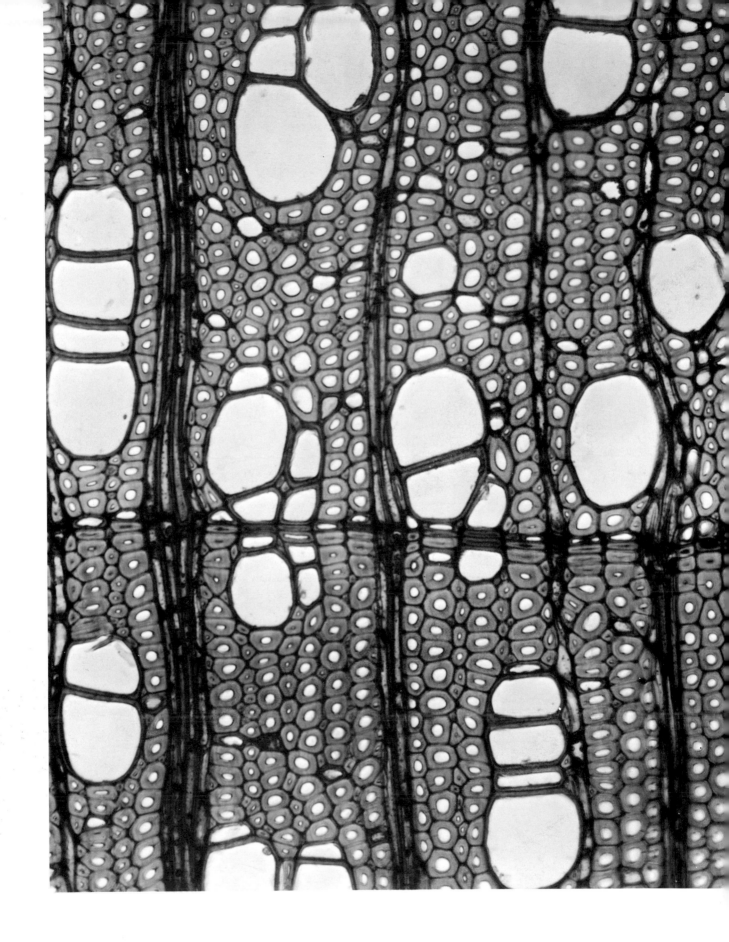

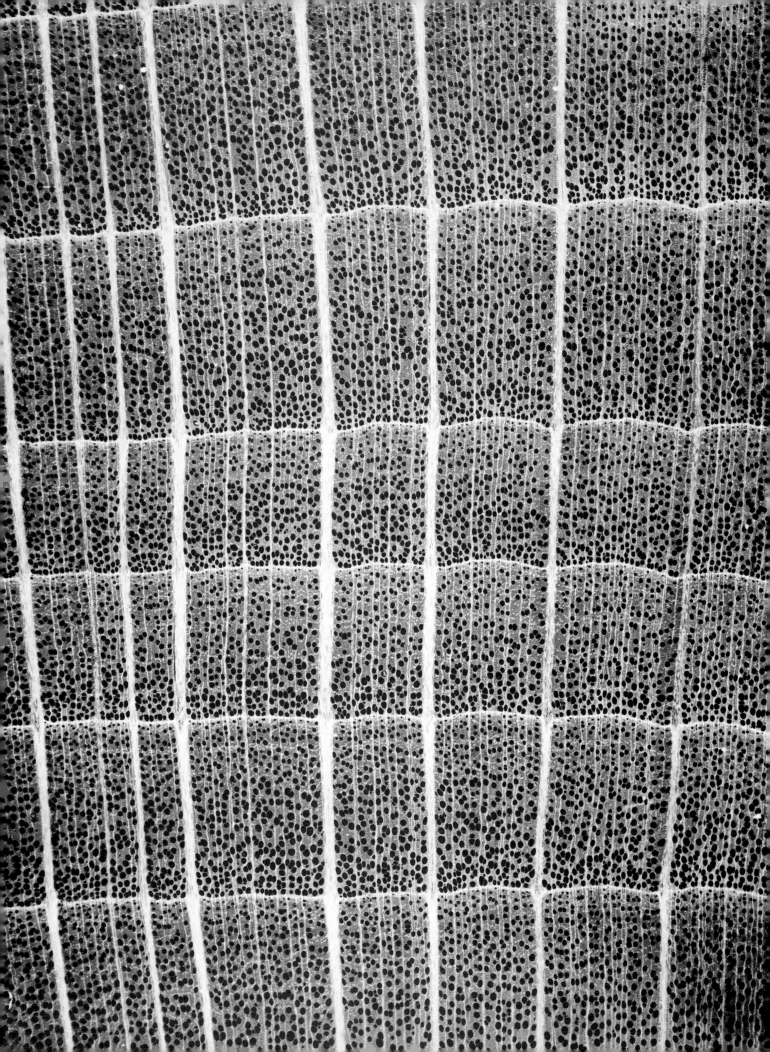

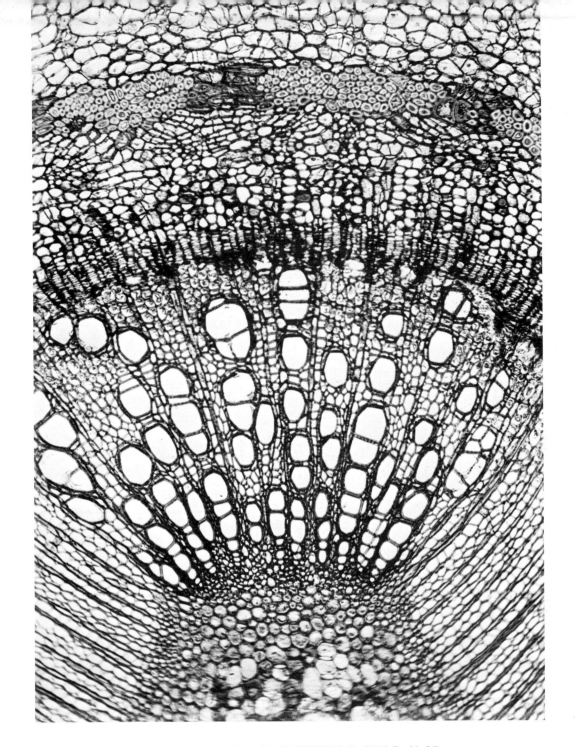

CROSS SECTION OF BUTTERNUT TWIG, X 25

Juglans cinerea L.

This pattern of radial symmetry shows how a portion of a butternut twig looks near the end of the first growing season. The bottom center is one point of the star-shaped pith at the center of the twig.

Opposite: CROSS SECTION OF AMERICAN BEECH WOOD, X 10

Fagus grandifolia Ehrh.

This looks something like the illustration of sycamore, but beech wood is heavier—more wood substance, less air space.

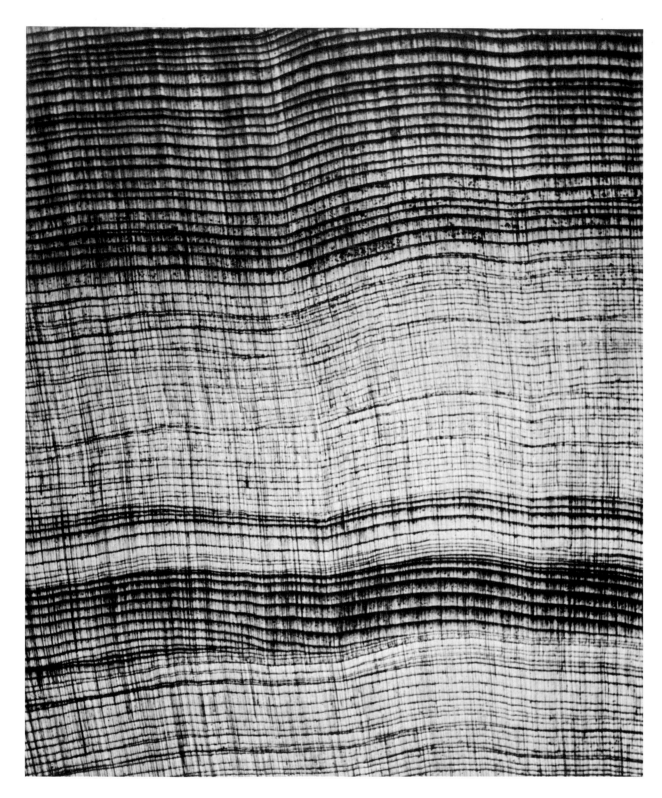

CROSS SECTION OF REDWOOD WOOD, X 5
Sequoia sempervirens (D. Don) Endl.
Redwood, like all other conifers, has no specialized sap-conducting tubes.
These primitive woods consist mainly of long, hollow, closely packed tracheids
or fibers so small that they do not show at this magnification. The extremely
narrow rings characterize old, slowly growing trees. How many years did it
take this sample to grow? Each ring has light earlywood and dark latewood.

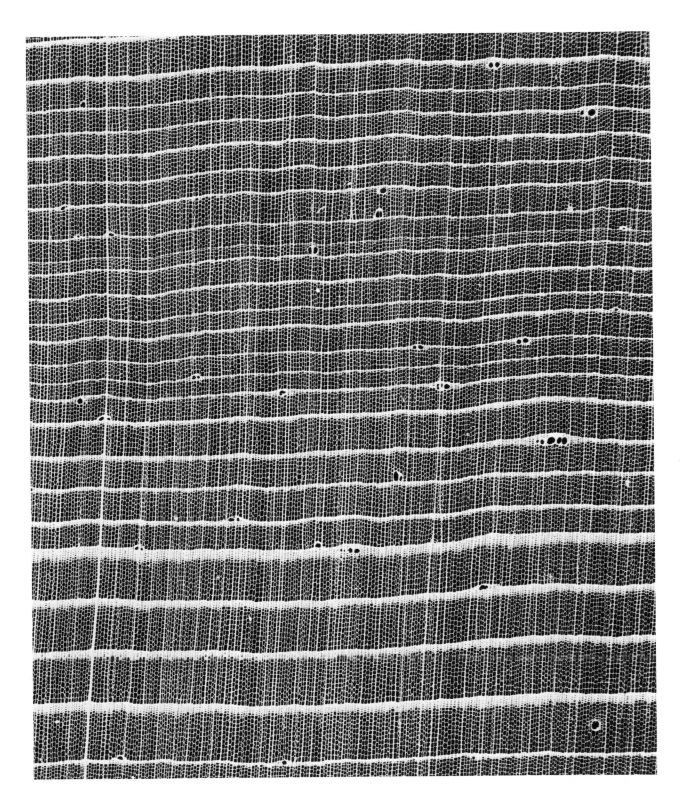

CROSS SECTION OF WESTERN LARCH WOOD, X 15
Larix occidentalis Nutt.

At this magnification, we can begin to see its beautiful lace-like texture. In 1682, Nehemiah Grew, one of the very first to view plant tissues through a primitive microscope, was so entranced that he wrote, ''The Staple of the stuff is so exquisitely fine, that no silkworm is able to draw anything near so fine a thread. So that one who walks about with the meanest stick, holds a piece of Nature's Handicraft which far surpasses the most elaborate Woof or Needle-work in the World.''

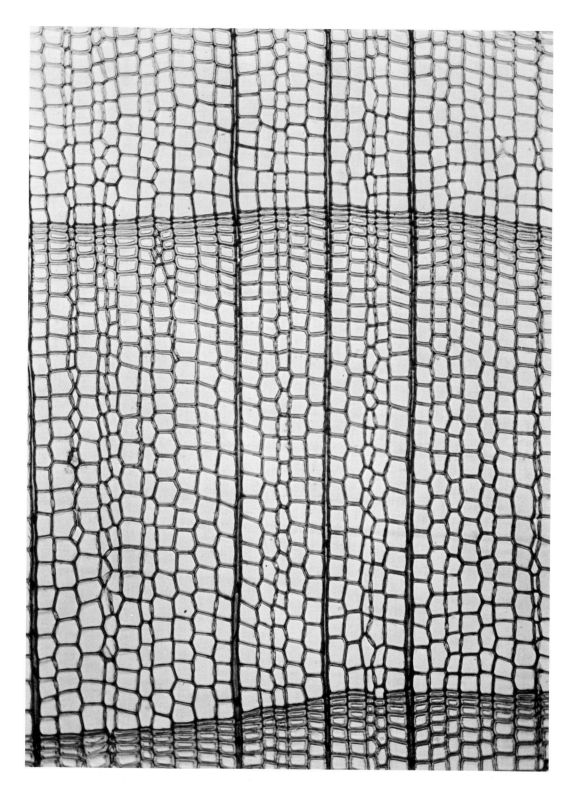

CROSS SECTION OF NORTHERN WHITE-CEDAR WOOD, X 125
Thuja occidentalis L.

Once again the beautifully even structure of a coniferous wood is revealed.
And yet no one cell is exactly the same size and shape of any other cell. This
is true throughout the whole world of nature. There are recognizable repeated
patterns, but each individual is unique.

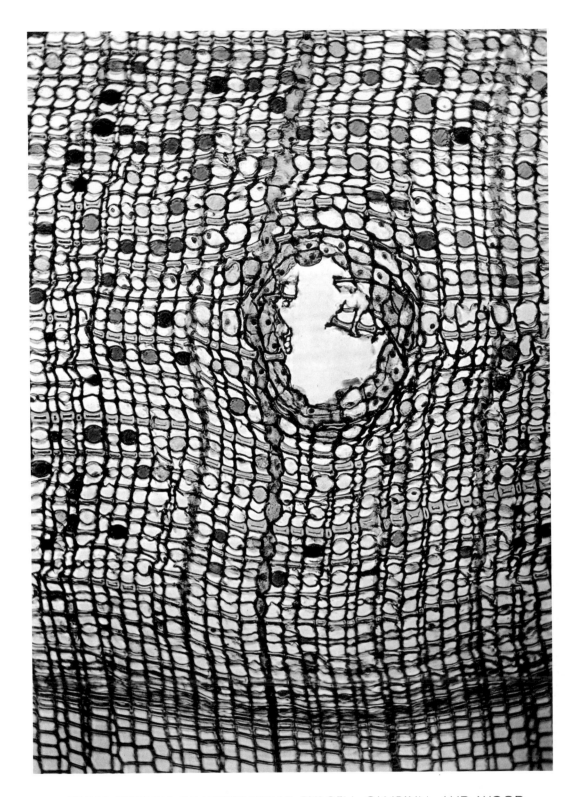

CROSS SECTION OF WHITE-CEDAR PHLOEM, CAMBIUM, AND WOOD,
X 125
Thuja occidentalis L.

The outer part of a growth ring is being formed at the bottom of the picture. Most of the area above shows a number of years' growth of phloem (inner bark) with a large included resin canal. There are several rows of very narrow cells between wood and phloem. One of these rows is the cambium. During the growing season, its cells divide millions of times, around and up and down the tree, forming wood on the inside (toward the tree's center) and bark on the outside. See also Notes on Plant Characteristics, p. xii.

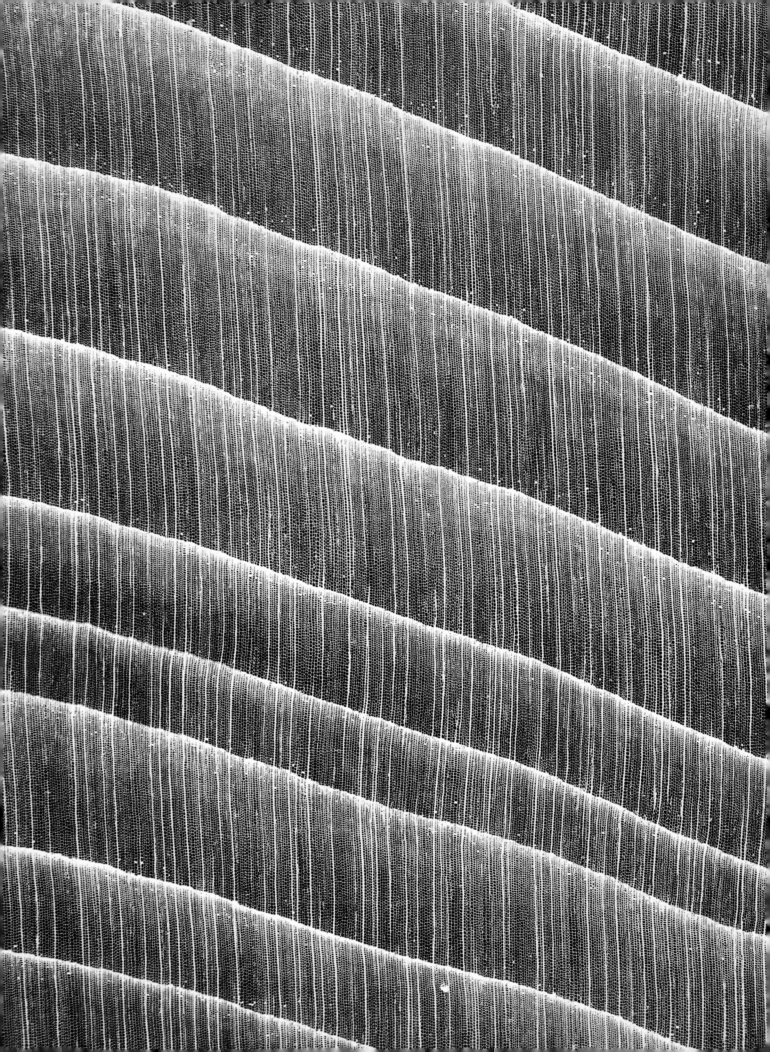

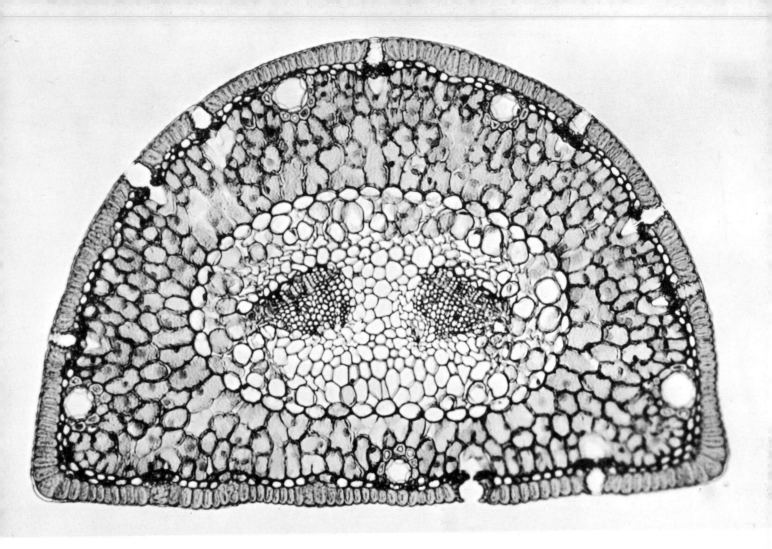

CROSS SECTION OF MOUNTAIN (MUGO) PINE NEEDLE, X 150

Pinus mugo Turra.

Coniferous needle cross sections are things of beauty as well as of utility. Like other green leaves, these needles make food which the tree consumes in order to grow. Notice the openings around the outer edge. The flat side nearest the center was sectioned to reveal the two guard cells which can change shape to regulate the size of the opening and the amount of air that circulates (diffuses) through the wide band of green cells all around the needle, just inside the outer protective layer. Here, using the sun's energy, the green chlorophyll acts as a catalyst to split molecules of water and carbon dioxide. Molecules of simple sugars are built and oxygen is released as a by-product. Were this process to stop, every plant and animal on earth would soon be dead.

Opposite: CROSS SECTION OF INCENSE-CEDAR WOOD, X 15

Libocedrus decurrens Torr.

The name tells you something about this wood. There are no true cedars native to the North American continent, hence the hyphen in the common name. The most famous cedar *(Cedrus)* is the Cedar of Lebanon, mentioned so many times in the Bible, and used to build Solomon's temple.

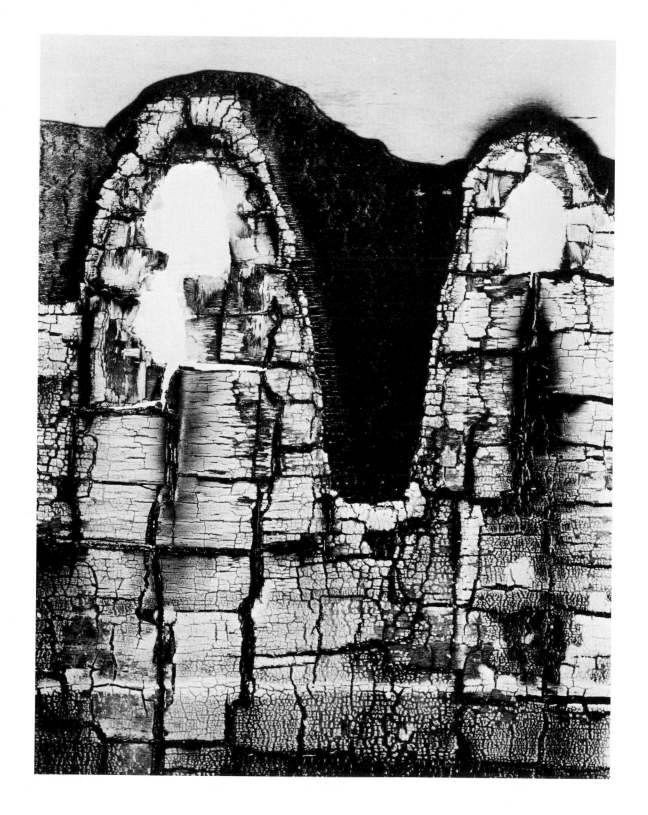

BURNED WOOD SURFACE
One might take this to be a photograph of the ruins of an ancient cathedral. This is a piece of plywood used in a fire test. Large wooden beams are more fire resistant than usually supposed, the first-formed charcoal (opposite) insulating the wood underneath.

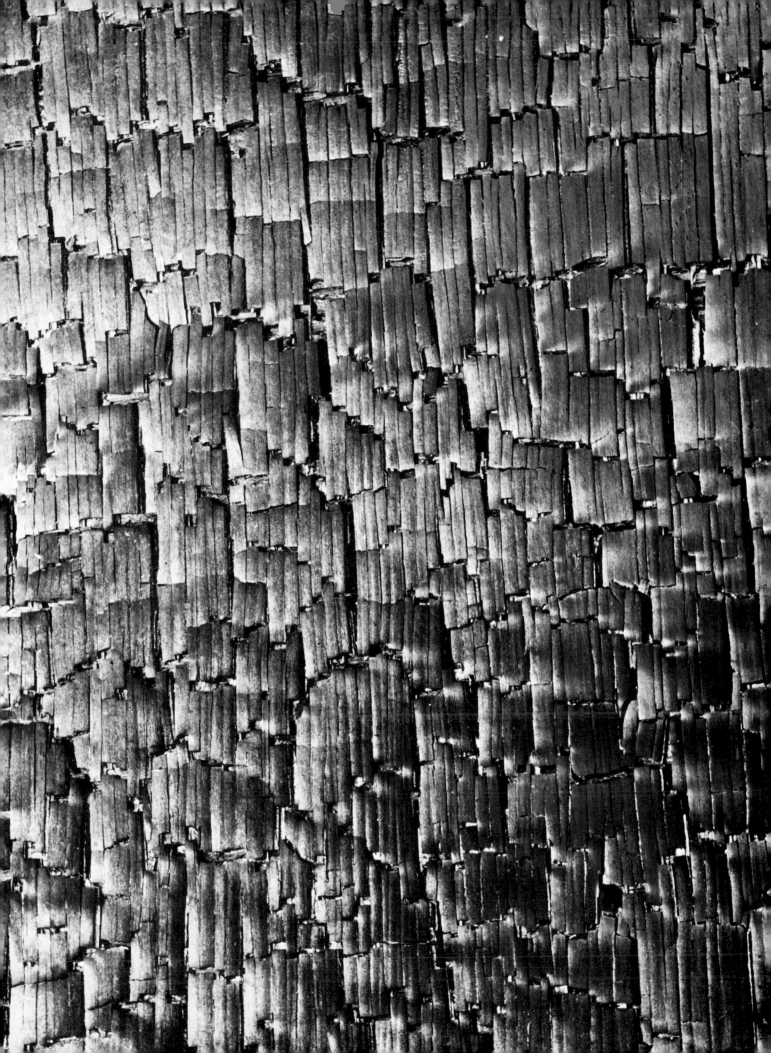

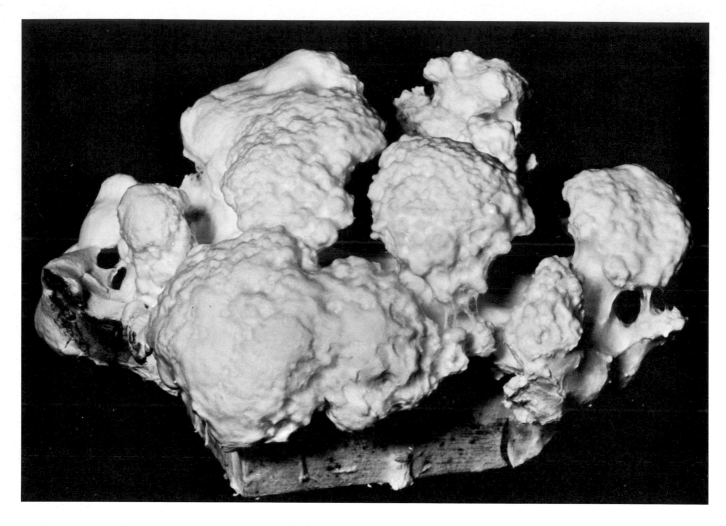

GROWTH OF A FUNGUS
Polyporus anceps Pk.

Few people have ever seen the actual body of a fungus. A small block of ponderosa pine wood was inoculated with this fungus, placed in a large, loosely stoppered wide-mouthed bottle and left in a warm, moist chamber for one year. It was fascinating to observe the fungal growth at one-month intervals. How often patterns in nature are similar! The billowing pure white fungus body looks like cumulus clouds in a summer sky. In the forest it would be very rare to see such a growth. The creeping threads of the fungus would be hidden inside the moist wood being decayed. As enzymes from the fungus digest the wood, it loses weight, becomes weak and finally may fall to pieces. Its small amounts of contained minerals go back to the earth from which they came. Fungi are usually considered to be our enemies, but without them, dead and fallen trees would pile up, leaving no space for new trees to grow.

Opposite: RAINBOW FUNGUS
Polyporus versicolor L.

This is the visible part of the rainbow fungus—so called because the edges of the scalloped fruiting body (conk) are beautifully multicolored. The under-surfaces of these scalloped edges are covered with pores from which stream billions of spores. By the time the conks appear, a process taking years, the branching network of fungal threads inside the tree or piece of wood has already caused extensive decay which cannot be halted by removing the conk, as some people suppose.

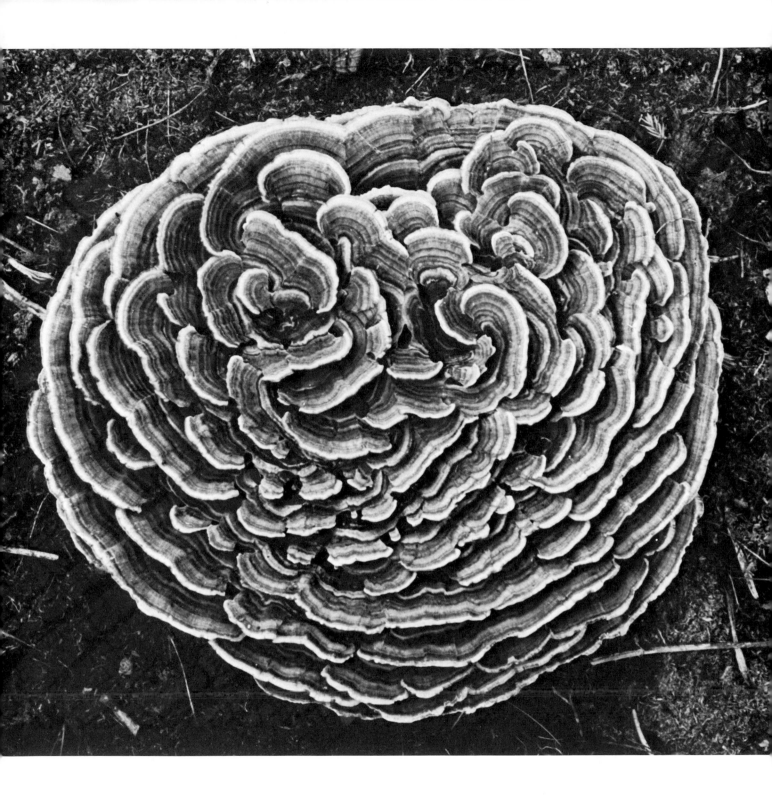

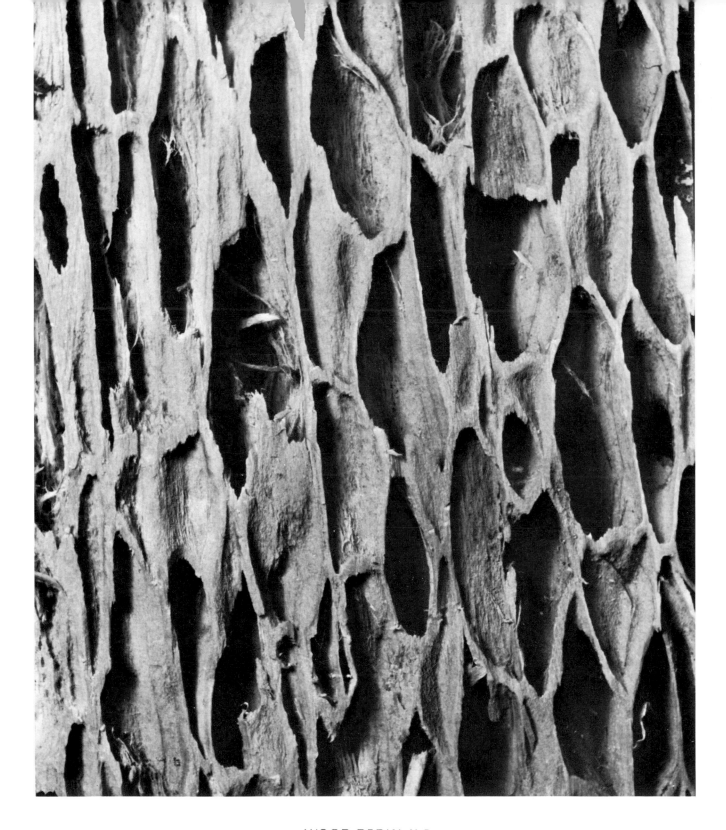

WOOD DECAY, X 2
The phrase "slow fire of decay" has some truth, both from the standpoint of appearance and the end products of the two processes—carbon dioxide and water.

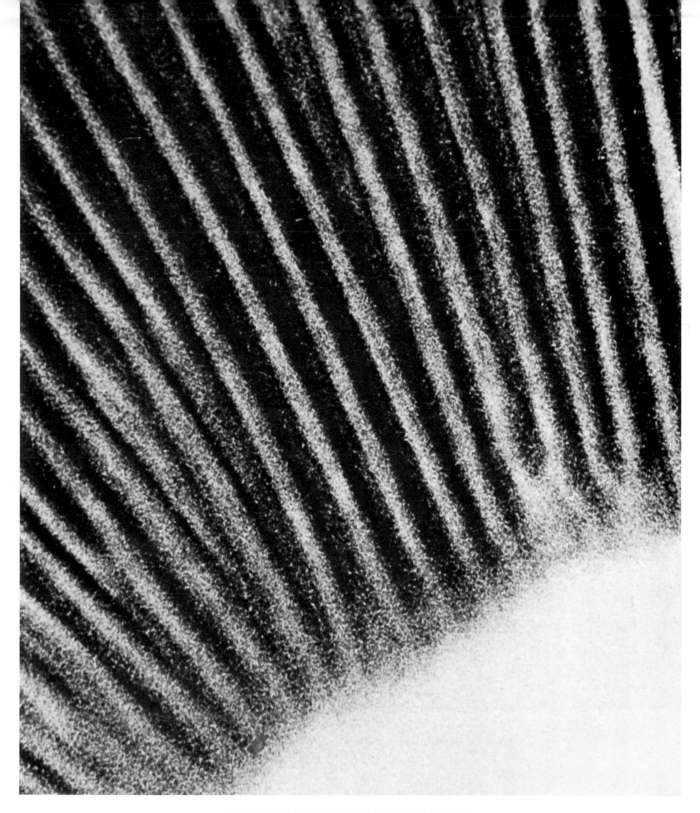

COMMON MUSHROOM SPORE PRINT
Agaricus campestris Fries

If you look at the undersurface of the common edible mushroom or other gill fungus, you will find a beautiful radial pattern of the gills. Cut off the stem and place the cap underside down upon a piece of white paper. Cover with a saucer to keep out air currents. After two to three hours, carefully remove the cap. This illustration is an enlarged view of what you will find. Under a microscope, you can see the spores—as numerous as the sand grains on a beach! It is fortunate that only a few fungous spores ever land in a suitable moist place where there is also food for them to germinate and grow. Otherwise, we might be inundated with mushrooms and other kinds of fungi.

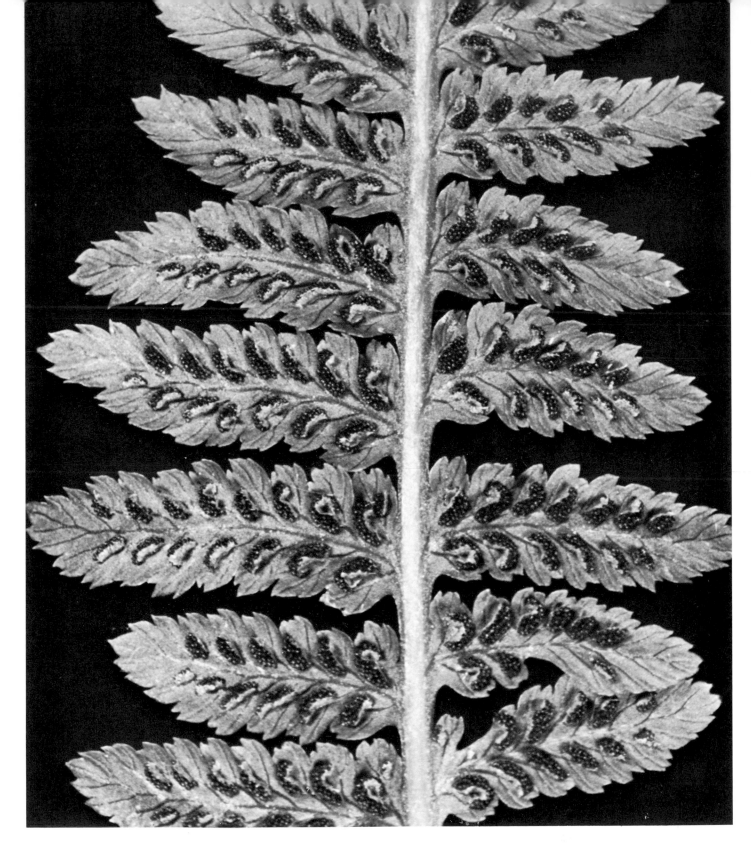

FRUITING DOTS OF LADY FERN
Athyrium felix-femina (L.) Roth

Many people have found these fruiting dots *(sori)* on the underside of ferns used as house plants, and have assumed that the plant was diseased! With a hand lens, you can see clusters of tiny black spheres growing along the edge of each cave-like flap—the whole structure is called a *sorus*. On a single fern plant there must be millions of these little black *sporangia*. When they open, billions of microscopic spores are released and drift away in the wind. Some of them, landing in a cool moist place, may sprout and new ferns begin to grow.

INDEX OF PLANTS

(Numbers refer to the page on which a plant is illustrated.)